Pittsburgh
1900–1945

To Jeff
From Cousin Bill
12-25-13

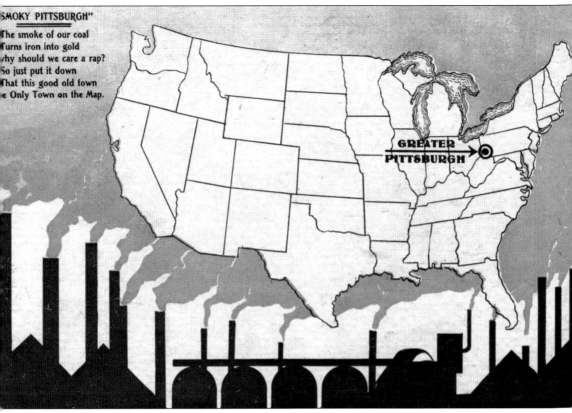

This 1915 postcard sums up perception and reality of early-20th-century Pittsburgh. The city was the center of heavy manufacturing in the United States, the capital of the American iron, steel, oil, and glass industries. Smoke was viewed by Pittsburghers as a visible symbol of prosperity in spite of the environmental and health problems that it caused. During the Pittsburgh Renaissance of the 1950s, industrial air pollution was greatly reduced. (Courtesy of John DeSantis.)

On the front cover: Pittsburgh's history and development have been shaped by the three rivers at the heart of the city, the surrounding hills, and the heroic efforts required to span them. This early-1930s view of the Golden Triangle focuses on the Point, framed by the Manchester Bridge on the left (1913–1970) and the second Point Bridge on the right (1927–1970). (Author's collection.)

On the back cover: The 1892 Sixth Street Bridge (also known as the Federal Street Bridge) spanned the Allegheny River, connecting the cities of Pittsburgh and Allegheny. The powerful steel and cast-iron construction possesses a heavy grace, in a way epitomizing the city it serves. When this bridge was replaced in 1927, it was dismantled, floated downriver on barges, and reassembled at Neville Island to serve for an additional 67 years. (Author's collection.)

POSTCARD HISTORY SERIES

Pittsburgh
1900–1945

Michael Eversmeyer

ARCADIA
PUBLISHING

Published by Arcadia Publishing
Charleston, South Carolina

Printed in the United States of America

Library of Congress Control Number: 2008932668

For all general information contact Arcadia Publishing at:
Telephone 843-853-2070
Fax 843-853-0044
E-mail sales@arcadiapublishing.com
For customer service and orders:
Toll-Free 1-888-313-2665

Visit us on the Internet at www.arcadiapublishing.com

*Dedicated to the people of Pittsburgh, past and present, whose loyalty,
strength, and hard work have made this city great.*

CONTENTS

Acknowledgments 6

Introduction 7

1. Bridges and Rivers 9

2. The Golden Triangle 21

3. North of the Allegheny 35

4. South of the Monongahela 47

5. East of the Triangle 61

6. Oakland 73

7. East Liberty 85

8. East End Neighborhoods 97

9. Pastimes 115

ACKNOWLEDGMENTS

The author wishes to thank everyone who helped with the preparation of this book, especially those who gave of their time, their knowledge, and their postcard collections: John DeSantis; Marilyn Evert; Martin Fuess; David Grinnell, Library and Archives Division, Sen. John Heinz History Center; Judith Harvey; Art Louderback, Library and Archives Division, Sen. John Heinz History Center; Alexis Mackin, Library and Archives Division, Sen. John Heinz History Center; Greg Priore, William R. Oliver Special Collections Room, Carnegie Library of Pittsburgh; Albert Tannler, Pittsburgh History and Landmarks Foundation; and Timothy Zinn.

At the end of each caption, the key to the source of the image is given in parentheses. The images in this book appear courtesy of the following individuals and organizations: collection of the William R. Oliver Special Collections Room, Carnegie Library of Pittsburgh (CLP); Library and Archives Division, Sen. John Heinz History Center (HHC); collection of John DeSantis (JDS); collection of Judith Harvey (JH); and collection of the Pittsburgh History and Landmarks Foundation (PHLF).

Where no source key is given, the postcard image appears courtesy of the author's collection.

INTRODUCTION

A decade ago, my wife, determined that I should have a hobby, presented to me on my birthday an album and a stack of postcards—a not-very-subtle hint that I should form a collection. Since then, I have enjoyed searching for and collecting two kinds of postcards: county courthouses (for the thrill of the hunt) and town views of Pittsburgh. Pittsburgh interests me particularly because it is my adopted hometown and the focus of my fascination with architecture and history. The city has also been a major factor in the history and development of the United States and so provides abundant material for research and writing.

Pittsburgh, from its 18th-century founding as a strategic military installation to its 20th-century role as a leading industrial center, has played an integral part in the development of the nation. Although the era of heavy industry has passed, Pittsburgh today is a major American city, a center of higher learning, a global destination for medical care, and a base for research in computer science, robotics, medicine, and many other fields. First as a frontier outpost, then as a transportation center, a "jumping off place" for Western settlement, and home to nation-building industries, Pittsburgh's place in American history is such that if the city had not existed, it would have had to be invented.

A full list of nationally important people associated with Pittsburgh would be too long to include here, but a few can be mentioned, including industrialists Andrew Carnegie, Henry J. Heinz, and George Westinghouse; banker Andrew Mellon; movie star Gene Kelly; environmentalist Rachel Carson; organ transplant pioneer Dr. Thomas Starzl; songwriter Stephen Foster; journalist Nellie Bly; and sports heroes Joe Montana, Lynn Swann, and Mario Lemieux.

Not quite an eastern city but not a Midwestern one either, Pittsburgh has a unique appearance, history, and flavor and yet in human terms has much in common with most other American cities one could name. It is hoped that this book illustrates these features through a selection of postcards made between 1900 and 1940.

It is a fortuitous coincidence that postcard publishing and collecting were most popular in the early decades of the 20th century, just as Pittsburgh was becoming a city of national importance. It was only in 1898 that the federal government permitted the mailing of single cards. At first, the post office permitted the back of the postcard (the unillustrated side) to be used only for the address, limiting messages to the picture side. These undivided-back postcards were better than nothing, but when the rules were changed in 1907 to allow divided backs—so that one half could contain a message and the other the address—the postcard boom really began.

Mailing and collecting the cards became a national (and international) fad, and publishers rushed to keep up with the demand for postcards of all kinds. Photographers were dispatched to

cities and towns all over the country to record scenes of interest. Thus there is a vast selection of postcard views of skyscrapers, city halls, market houses, bridges, mansions of the wealthy, churches, and schools from the early 20th century. Views that were considered mundane at the time, including middle- and lower-class neighborhood street scenes, vehicles, and everyday retail establishments, were less frequently recorded. Businesses were not slow to grasp the advertising potential of postcards, and these now provide an invaluable and sometimes amusing record of commercial activity.

The postcard craze peaked just before World War I when the U.S. Postal Service reported that Americans mailed a billion of them in 1913. The war, declining quality, and increased use of the telephone contributed to the waning of the postcard fad. Postcards never disappeared, of course, but the quality and quantity of cards and views declined over the next several decades. They probably reached their nadir in the 1930s and 1940s with the introduction of cheaply printed linen postcards whose garish colors and lack of detail are unattractive to many collectors. However, to gain any insight into the views illustrated by postcards in the years preceding World War II, linen postcards must be collected and studied.

Pittsburgh's ascendancy as an industrial center was most dramatic right after the dawn of the 20th century. As the iron, steel, and glass industries in Pittsburgh were consolidated, money was available to rebuild downtown Pittsburgh, changing it from a walking city of the 19th century into a modern, central business district. The construction of office skyscrapers, banks, department stores, theaters, railroad stations, and government buildings completely changed the face of the city. Outlying areas burgeoned with new residents moving away from downtown, bringing with them their churches, schools, and businesses. Meanwhile, the social and cultural elite in Pittsburgh were creating a new civic center in the Oakland neighborhood two miles east of downtown, centered around the Carnegie Library and museums, including hotels, social clubs, monuments, and universities.

Every attempt has been made to select postcards that provide a good general view of the Pittsburgh of a century ago, using images that have not previously been published in this series. It is necessary to maintain a certain skepticism about these postcard views. Napoleon Bonaparte was supposed to have said, "History is a set of stories agreed upon." To a certain extent, the same can be said of postcards. Some publishers were not at all averse to "photoshopping" their images to make more interesting (and salable) postcards. The colorists who made the Monongahela Wharf green and the Carnegie Institute red; the artists who drew in pedestrians, automobiles, and streetcars to enliven street scenes; the fantasists who added imaginary buildings or landscape features to the horizon—all these laid traps for unwary historians and enthusiasts. The linen cards of the 1930s and 1940s are so artistically simplified, almost impressionistic, as to be often nearly useless as historical documents.

Pittsburgh: 1900–1945 begins with views of the bones of Pittsburgh: its rivers and bridges. The following chapters amount to a kind of tour of the city. First is downtown, the Golden Triangle of business and government, followed by the North Side (north of the Allegheny River) and the South Side (south of the Monongahela and Ohio Rivers) and then the hills and valleys east of downtown between the rivers. This large eastern area has been divided into the older, industrial neighborhoods east of the Triangle (including the Hill District, the Strip District, and Lawrenceville), Oakland (the Oakland Civic Center), and the East End neighborhoods that grew up after the dawn of the 20th century. Finally there is also a chapter of postcards of various diversions from everyday life that were enjoyed by Pittsburghers over the years.

One

BRIDGES AND RIVERS

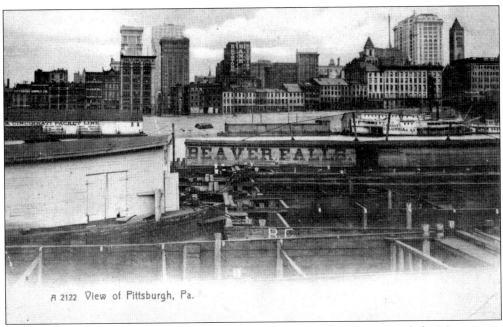

A 2122 View of Pittsburgh, Pa.

This 1905 postcard view was taken from the south bank of the Monongahela River across from downtown Pittsburgh. Vital commercial river traffic is represented by the wooden barges and towboat in the foreground and the packet offices and riverboats on the far side along the Monongahela Wharf. Most of the warehouses lining the wharf had served river traffic since before the Civil War. (JH.)

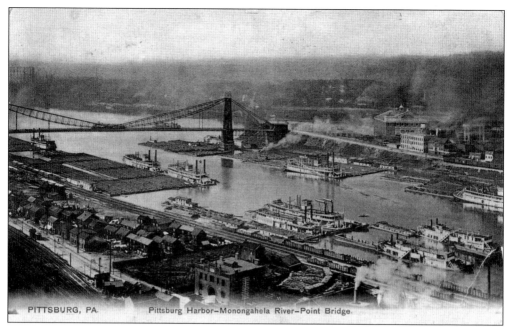

This view of the Point, taken in 1907, illustrates the variety and intensity of traffic on Pittsburgh's three working rivers a century ago. Riverboats, towboats, and barges line both banks of the Monongahela River in the foreground. The Point itself is wasteland, and Pittsburgh's notorious smoke rises from all quarters. (PHLF.)

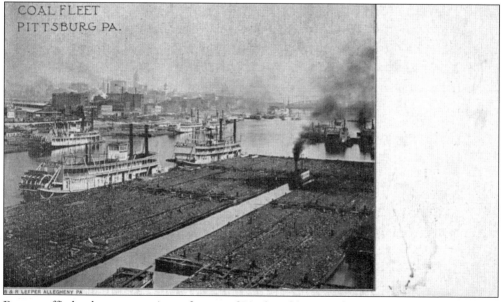

Barge traffic has been a prominent feature of Pittsburgh's rivers for over 100 years. One of the vital commodities carried on barges was coal, used for fuel and (as coke) in the manufacture of iron and steel. Before the lock-and-dam system guaranteed year-round navigability, river traffic regularly collected at Pittsburgh during low water to wait for rain to raise the river levels, as seen in this 1900 view.

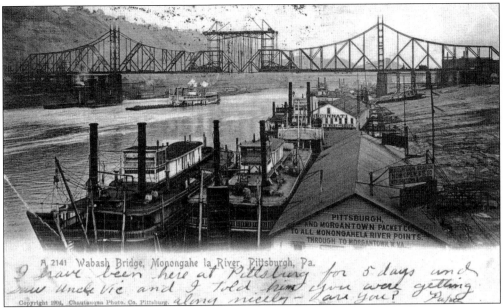

A 2141 Wabash Bridge, Monongahela River, Pittsburgh, Pa.

I have been here at Pittsburg for 5 days and saw Uncle Vic and I told him you were getting along nicely — are you? Papa

Copyright 1904, Chautauqua Photo. Co. Pittsburg.

There are many postcards of the Wabash Railroad Bridge, but this 1904 view is unusual in its depiction of the final stage of construction of the bridge. The self-supporting cantilevered arms of the bridge are being joined by a truss section that will be suspended between them to complete the span. Until 1948, trains crossed this bridge to the Wabash Terminal downtown after tunneling through Mount Washington. (PHLF.)

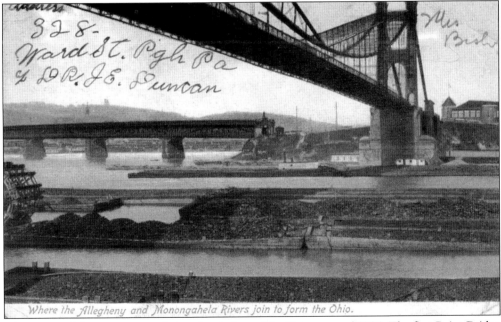

328- Ward St. Pgh Pa & D. R. J. E. Duncan

Mrs. Bishr

Where the Allegheny and Monongahela Rivers join to form the Ohio.

This postcard shows an unusual river-level view of the Point around 1905. The first Point Bridge (an 1876 suspension bridge with peculiar trussed catenary cables) crosses the Monongahela River overhead. The 1874 Union Bridge, in the distance, was a late-surviving wooden covered bridge between the Point and Manchester. It was declared a hazard to shipping and demolished during World War I. The Point at this time was largely undeveloped. (JDS.)

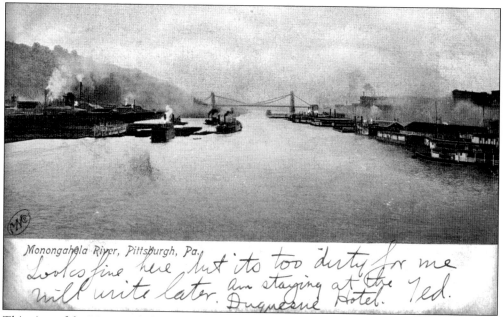

Monongahela River, Pittsburgh, Pa.

Looks fine here but its too dirty for me will write later. Am staying at the Duquesne Hotel. Ted.

This view of the Monongahela River, probably taken from the Smithfield Street Bridge looking toward the Point Bridge, captures the ambience of Pittsburgh's working rivers around 1902. Riverboats nose onto the Monongahela Wharf on the right, while others ply the crowded stream among the coal barges. Thick smoke rises from both banks, inspiring the sentiment written below the picture. (JDS.)

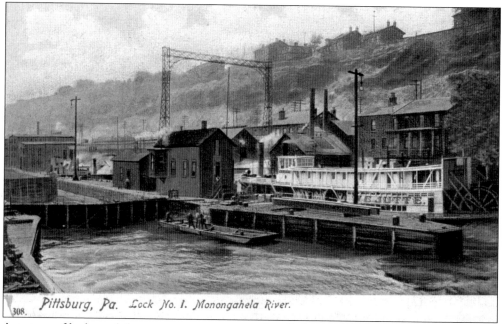

Pittsburg, Pa. Lock No. 1. Monongahela River.

A system of locks and dams was necessary to make all three of Pittsburgh's rivers navigable year-round. The first lock and dam on the Monongahela River upstream from the Point, built in 1902 and shown here in 1908, was located below the bluff. This dam became obsolete with the construction of the 1922 Emsworth Dam on the Ohio River. (CLP.)

12

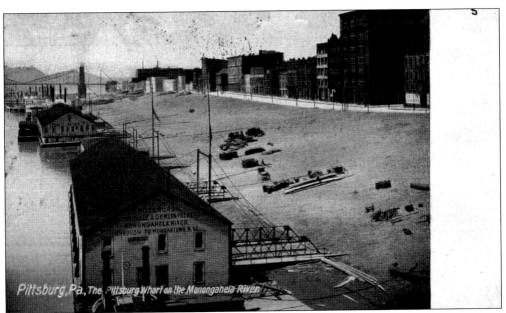

Pittsburg, Pa., The Pittsburg Wharf on the Monongahela River

This postcard shows the Monongahela Wharf area before construction of the Wabash Railroad Bridge began in 1902. The riverboat offices in the foreground sold tickets for passage up the Monongahela River and down the Ohio River. Riverboats loaded and unloaded on the sloping wharf before transferring goods to the warehouses along Water Street. The block of warehouses to the left of the seven-story Conestoga Building (1890) is still standing. (CLP.)

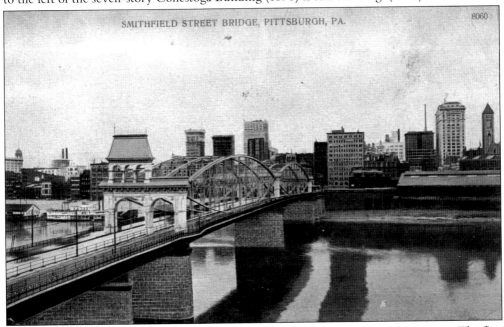

SMITHFIELD STREET BRIDGE, PITTSBURGH, PA. 8060

The Smithfield Street Bridge is the principal route from the South Side to downtown. The first bridge on this site, a wooden covered bridge, was built in 1818 and burned in the great fire of 1845. This bridge, designed by the famous engineer Gustav Lindenthal with an unusual pair of steel and wrought iron lenticular trusses, was completed in 1883 and is still in use. This postcard dates from 1910. (JDS.)

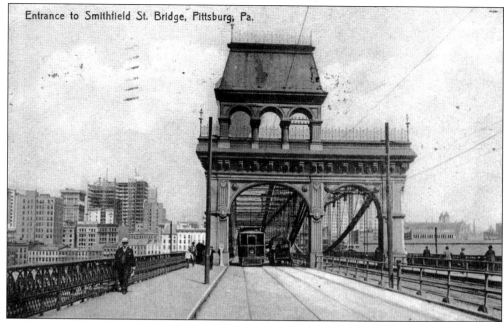

Through the years, the Smithfield Street Bridge has been adorned by a variety of portals. The arch on the right was added to the original two-level portal after the bridge was widened in 1891. Shown here in 1908, this portal was replaced in 1915 by the structure in place today. The ornate railing on the left has been reused at the current Station Square light rail transit station. (JDS.)

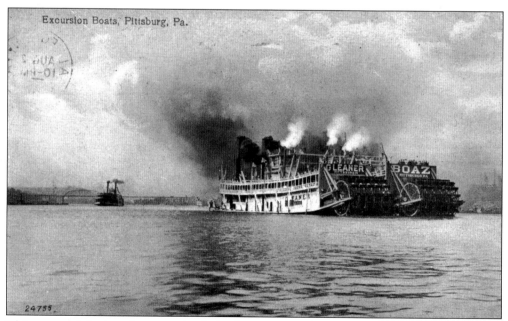

Excursion Boats, Pittsburg, Pa.

This postcard depicts the sternwheel riverboats *Boaz* and *Gleaner* during a river parade in Pittsburgh in 1908. Both plied the Ohio River and its tributaries as packets and towboats; the *Boaz* operated from 1882 to 1925. The two boats were hitched together as a reference to the story of Boaz and the gleaners in the Book of Ruth.

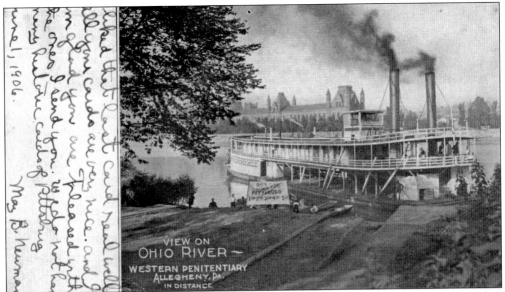

Before automobiles became common and road networks improved, excursion and packet boats carried travelers to and from Pittsburgh on regular schedules and special occasions. One such riverboat, the *Florence Belle*, is seen in this 1906 postcard with its makeshift landing on the Ohio River shoreline at McKee's Rocks. Across the river on the Allegheny side, the Romanesque-style second Western Penitentiary building can be seen. (JH.)

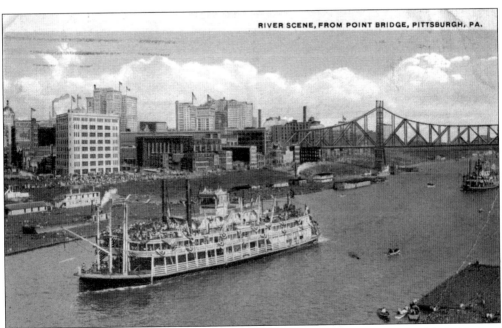

Riverboat excursions were a popular pastime well into the 20th century. In this 1915 view, the gaily bedecked *Steel City* is heading downstream past the Monongahela Wharf. This boat, originally called *Virginia*, was an accident-prone vessel famous for running aground in a cornfield during a 1910 Ohio River flood. It was renamed the *Steel City* between 1912 and 1916 and continued working the rivers until 1927.

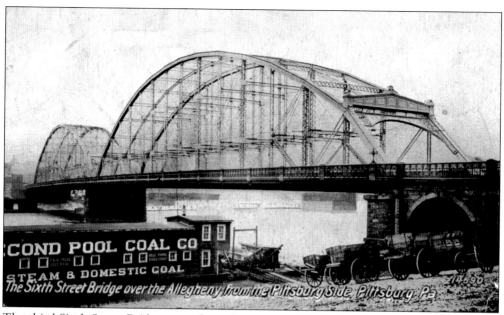

The third Sixth Street Bridge, seen from the Pittsburgh side in 1912, was built in 1892. Its straightforward arched trusses were visually enlivened by ornamental portals, typical of the period. To make way for the current bridge, this one was floated downstream to Neville Island and reused for many years. The "pool" in the coal company's name refers to the river pools formed by the lock-and-dam system.

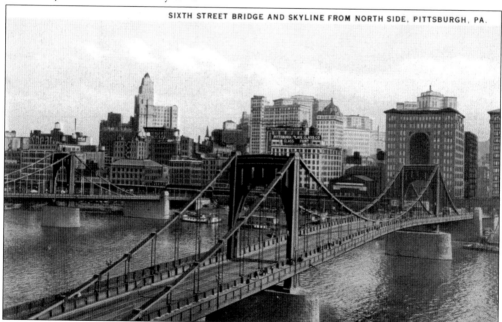

This 1930 postcard shows the Allegheny riverfront shortly after the county constructed the Three Sisters bridges at Sixth (foreground), Seventh, and Ninth Streets. Built to identical design at the insistence of the city's art commission, the bridges helped to aesthetically unify the disparate waterfront elements. This view also captures the brief moment in 1929 between construction of the Koppers and Gulf Buildings on Grant Street in the distance. (JDS.)

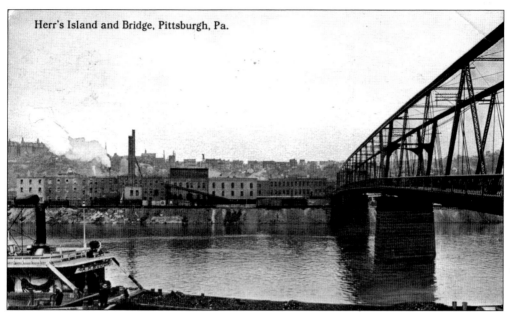

Herr's Island and Bridge, Pittsburgh, Pa.

In the late 19th century, federal law mandated that railroads carrying Midwestern livestock to eastern markets must stop to feed and water the animals. Pittsburgh, the approximate halfway point, was chosen as the site. Stockyards and ancillary businesses, including meatpacking plants, rendering plants, and tanneries, were built on Herr's Island in the Allegheny River. The railroad bridge shown here in 1913 still stands, although enlarged and strengthened. (PHLF.)

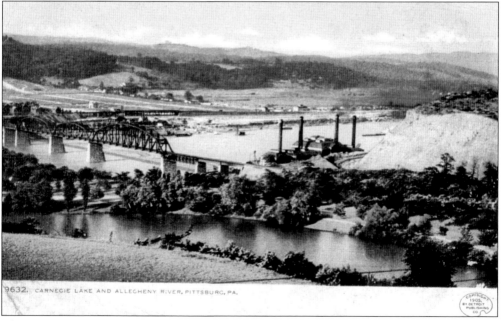

9632. CARNEGIE LAKE AND ALLEGHENY RIVER, PITTSBURG, PA.

This 1905 postcard was taken from Highland Park looking north to the Allegheny River. In the foreground is Lake Carnegie, a feature of the park; beyond it is the Pennsylvania Railroad's Brilliant Cutoff Bridge and the Brilliant Pumping Station (long since demolished). This part of the Allegheny has served as a water supply for the East End since 1907. The city waterworks would soon be constructed on the far bank.

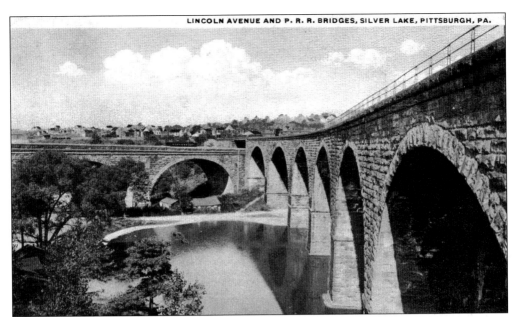

In the early 20th century, the Pennsylvania Railroad engaged in a massive building program, constructing numerous bridges and viaducts across the city's streets and ravines. Engineers often relied on technology as old as the Romans, including stone arch construction, as seen in this 1920 view of the Brilliant Cutoff Viaduct crossing over Silver Lake. The concrete arched Lincoln Avenue bridge over Washington Boulevard passes under the viaduct. (PHLF.)

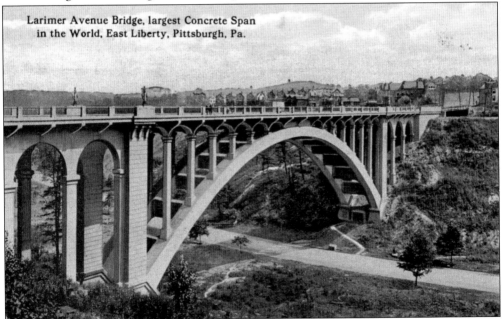

Larimer Avenue Bridge, largest Concrete Span
in the World, East Liberty, Pittsburgh, Pa.

In the early 20th century, engineers experimented with various forms for the use of a new material, reinforced concrete. The 300-foot Larimer Avenue bridge over the Negley Run ravine, built in 1912 by the city, was actually the second-longest concrete span in the world (the postcard's claim notwithstanding). This bridge underwent major reconstruction in 1980, owing to rusting of its steel reinforcing members. (CLP.)

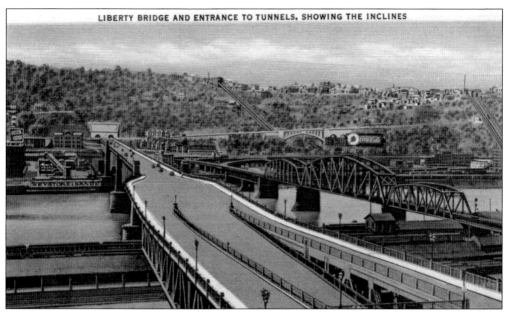

The Liberty Bridge and Tunnel project (shown here in 1941) marked the culmination of Allegheny County's massive bridge-building campaign of the 1920s. The bridge itself (completed in 1928) was not unique in structure; its significance lay in its connection with the Liberty Tunnels (or Tubes), completed in 1924, which made the bridge the gateway to the South Hills for those who commuted by automobile. (JDS.)

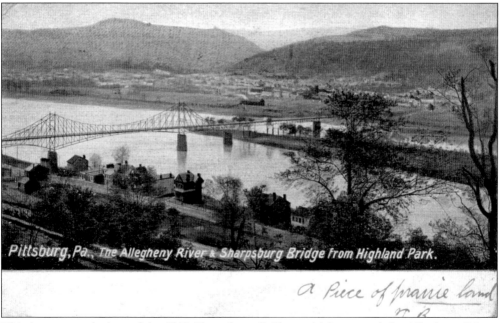

This is a postcard view of the 1902 Sharpsburg Bridge, which spanned the Allegheny River, connecting Baker Street in Pittsburgh with Nineteenth Street in the borough of Sharpsburg. Built to a lightweight curved-steel truss design, the bridge could not handle the increasing traffic load as communities north of the Allegheny River were developed. It was replaced in 1938 by the current Highland Park Bridge. (CLP.)

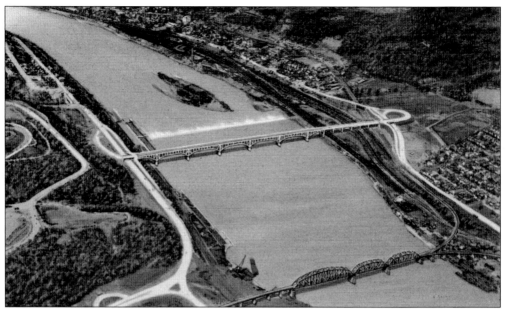

A new bridge across the Allegheny River at Highland Park was built about 2,000 feet upstream from the Sharpsburg Bridge. As with other contemporary bridges, including the Liberty and Homestead High-Level Bridges, the road deck was built atop the steel trusses. The white line above the bridge in this 1941 postcard is the Highland Park Dam, with its associated lock at left. (JDS.)

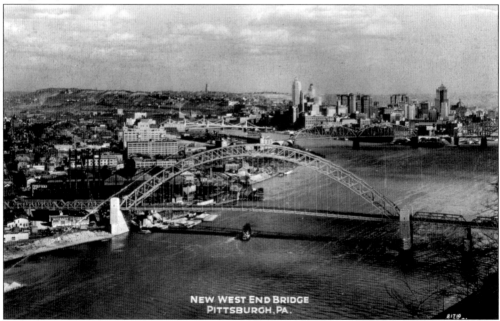

A crowning achievement of the county's 1920s bridge-building program was the West End Bridge, seen here in 1931. It was the first Pittsburgh bridge to span the Ohio River, connecting the West End valley to Manchester. The first local bridge to use a tied-arch structure, in which the steel roadway holds the ends of the steel arch together, it became the model for the Fort Pitt and Fort Duquesne Bridges. (PHLF.)

Two

THE GOLDEN TRIANGLE

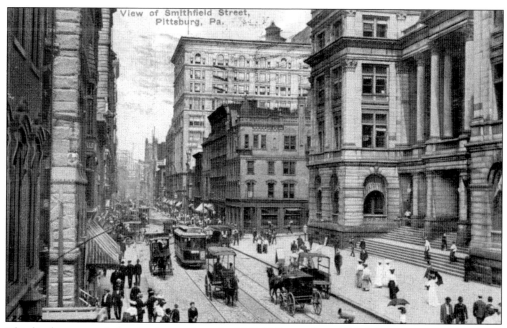

This lively postcard view looks north on Smithfield Street from Third Avenue at noontime on a warm day around 1911. The imposing stone building in the right foreground is the post office (built in 1891). It was demolished in 1966, and the site is now occupied by the Oxford Center garage. The tall building in the middle distance is Kaufmann's Department Store, built in 1898.

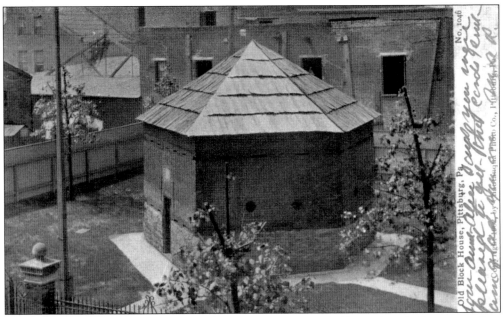

The Fort Pitt Block House, built by Col. Henry Bouquet in 1764, was largely forgotten when it was rescued in 1893 by Mary Croghan Schenley, largest private landowner in Pittsburgh, and donated to the Daughters of the American Revolution as a Colonial shrine. Stripped of residential additions by the time of this 1902 postcard, the restored blockhouse is now a noted feature of Point State Park. (JDS.)

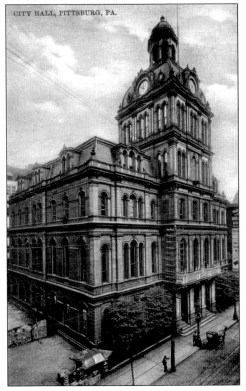

The 1854 city hall in Market Square was replaced in 1872 by this elegant building on Smithfield Street (where Saks Fifth Avenue stands today). The wealth of post-Civil War Pittsburgh is expressed in the mansard roofs and rich stone ornament of the Second Empire style. In 1917, city government migrated to the City-County Building on Grant Street. This building was demolished in 1952.

The management of the Hotel Antler on Fifth Avenue was enterprising in its use of advertising postcards even to the point of using the 1905 Avenue Theater fire for publicity. After a 1917 fire that destroyed the Avenue Theater and several other buildings, the Warner movie theater was built on the site. The Hotel Antler was remodeled in 1923 to contain a movie theater but has since been demolished.

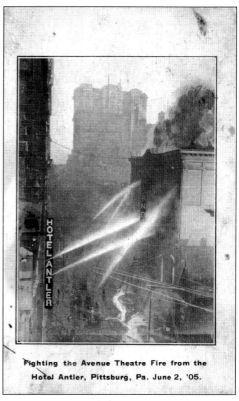

Fighting the Avenue Theatre Fire from the Hotel Antler, Pittsburg, Pa. June 2, '05.

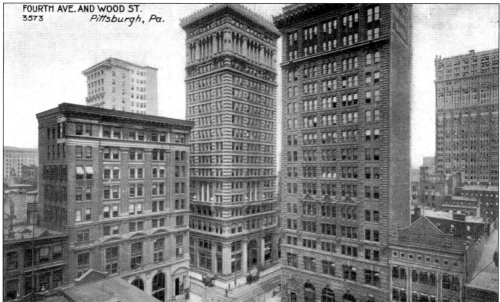

FOURTH AVE. AND WOOD ST.
3573 Pittsburgh, Pa.

The transformation of downtown Pittsburgh into a central business district after 1890 was most dramatically seen along Fourth Avenue, as banks vied to construct the newest and most extravagant buildings in the city's financial district. In this view from 1905, the Tradesman's Bank, Arrott, and People's Bank buildings anticipate construction of the Union Bank on the vacant fourth corner of Fourth Avenue and Wood Street.

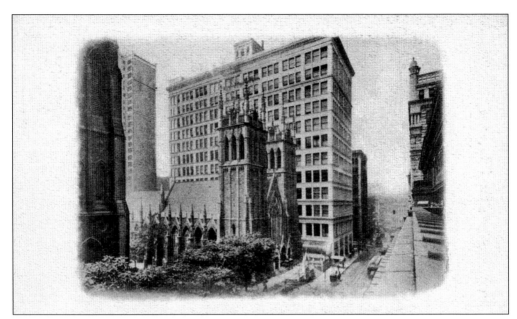

The Presbyterians were one of the denominations that received downtown land from the Penn family to build their first church in Pittsburgh. The current First Presbyterian Church on Sixth Avenue, designed by architect Theophilus Chandler, is shown in this 1906 postcard view. The previous church building was torn down to allow construction of the McCreery's Department Store building in 1903 (now 333 Sixth Avenue), behind the church on the right.

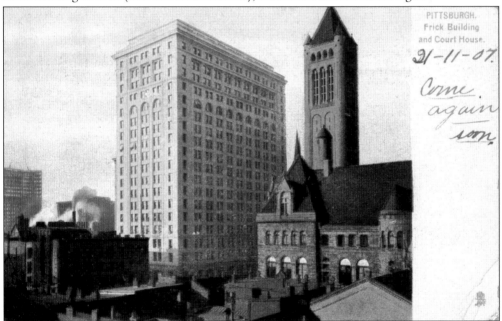

When it was completed in 1888, the tower of the Allegheny County Courthouse (Henry Hobson Richardson, architect) was the tallest structure in Pittsburgh. This symbolic dominance of the public sector in the life of the city was overshadowed by private interests in 1902 when Henry Clay Frick, the steel and coke tycoon, raised his namesake office building directly across Grant Street.

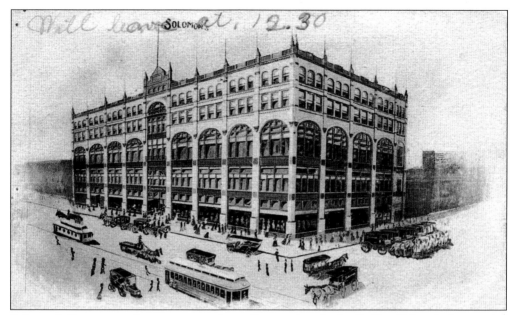

Solomon's Department Store was an early retail emporium in the Golden Triangle. It occupied the block on Smithfield Street between Fifth and Forbes Avenues across from the Kaufmann's Department Store building. Solomon's went out of business in 1907, the year this postcard was made. The Frank and Seder Department Store took over the building, which burned to the ground in the fire of January 1917. (PHLF.)

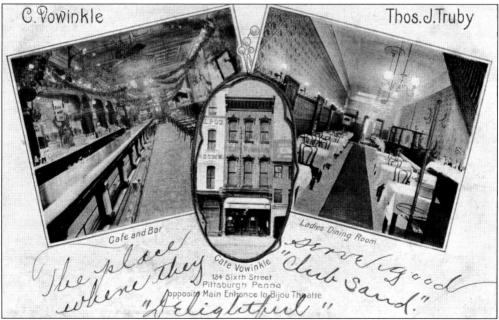

The Café Vowinkle stood at 124 Sixth Street, in the middle of the downtown theater district centered on the 600 block of Penn Avenue. This 1907 postcard is unusual in that it shows both the facade of the 1870s building and its principal interior spaces. While this building no longer stands, there remains a row of restaurants on Sixth Street that serves the city's contemporary Cultural District.

For much of its history, Market Square was not the open space familiar today. During most of the 19th and the early 20th centuries, the area was occupied by two large buildings flanking Market Street: Pittsburgh's first city hall and the 1854 Market House, shown here in 1909. Both buildings were razed and replaced in 1917 by a new and larger Market House, which was in turn demolished in 1961.

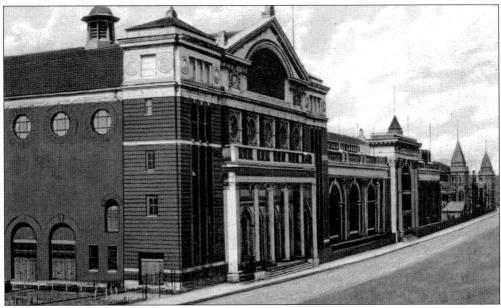

Inspired by world's expositions and local fairs during the decades spanning 1900, local entrepreneurs erected the Exposition Building and Music Hall in 1901 near the Point, to provide a permanent exhibition celebrating Pittsburgh industries and products. The space inside was also used for grand shows and spectacles and as a skating rink. These buildings (shown here around 1910) survived, although little used, until 1951. (JDS.)

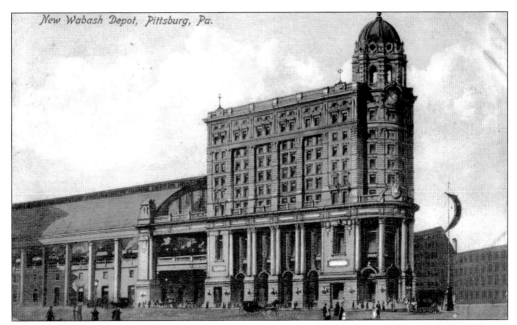

New Wabash Depot, Pittsburg, Pa.

In 1904, George Gould, son of famed robber baron Jay Gould, constructed the Wabash Railroad station near the Point as the outward symbol of his rivalry with the Pennsylvania Railroad. However, the Pennsylvania Railroad remained dominant in Pittsburgh. Gould's challenge failed; he declared bankruptcy in 1908. His spectacular Beaux-Arts terminal, shown here in 1910, was torn down in 1955 as part of the Gateway Center urban renewal project.

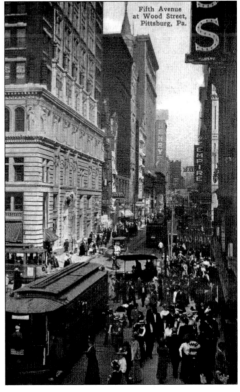

Fifth Avenue at Wood Street, Pittsburg, Pa.

This 1910 postcard depicts downtown Pittsburgh as the retail center of the region, with the streetcar network delivering throngs of shoppers to the Golden Triangle. Here at Wood Street along the north side of Fifth Avenue are the 1903 Farmers' Deposit Bank (with its statuary frieze at the third floor); the Masonic temple (before its move to Oakland); and looming in the middle distance, the Park Building (1896).

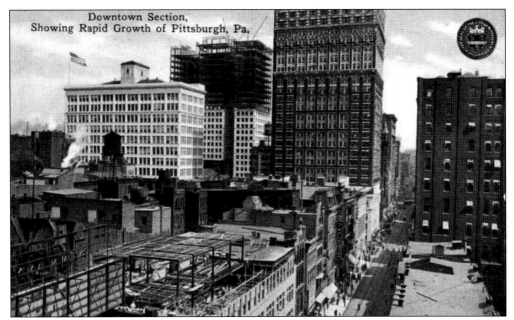

The early 20th century saw a boom in downtown skyscraper construction, evident in this view from 1909. Fifth Avenue, the principal shopping street, is visible on the right. The building under construction in the foreground on Market Street is the first Rosenbaum's Department Store building (demolished in 2007). In the background rise McCreery's Department Store (1903), the Oliver Building under construction, and the Farmers' Deposit Bank Building (1903).

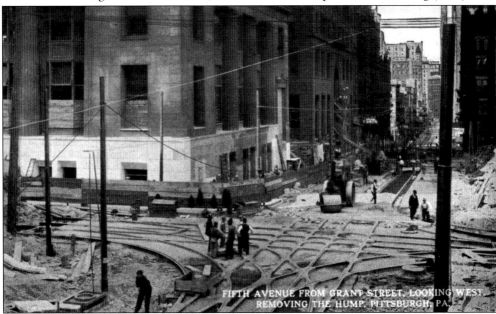

Between 1912 and 1914, the City of Pittsburgh engaged in a major civil engineering project to lower the street grade of Fifth Avenue at Grant Street. This 1914 view shows the installation of the web of streetcar track connections after excavation was completed. The depth of excavation is evident in the height of the new stone cladding at the base of the Frick Building on the left. (JDS.)

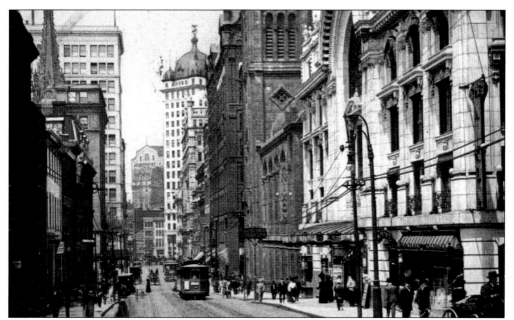

Sixth Avenue, viewed from Grant Street in 1909, was a lively section of the Golden Triangle. This postcard shows the Nixon Theater in the right foreground with the Smithfield German Church behind it. Trinity Cathedral's steeple rises on the left. Behind it are the McCreery's Department Store building, the domed Keenan Building, and the Natatorium Building in the distance. (JDS.)

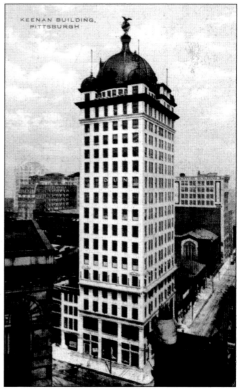

The Keenan Building, shown here about 1912, was an office tower commissioned in 1907 by the publisher of the *Pittsburgh Press*, Col. Thomas Keenan. This was the first high-rise to be built on the Allegheny River side of Liberty Avenue, anticipating the further spread of the office district. Rumor notwithstanding, the tiled dome at the top did not house an apartment and love nest for Colonel Keenan.

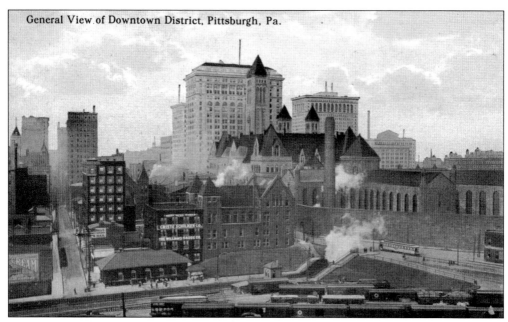

General View of Downtown District, Pittsburgh, Pa.

This postcard view of downtown Pittsburgh was taken around 1915 from the bluff where Duquesne University stands today. It shows the Allegheny County Morgue, Jail, and Courthouse, with the office towers of the Golden Triangle looming behind. The railroad in the foreground is the Panhandle branch of the Pennsylvania Railroad. Trains leaving the small station here entered a tunnel (where smoke is rising) to reach Union Station. (JDS.)

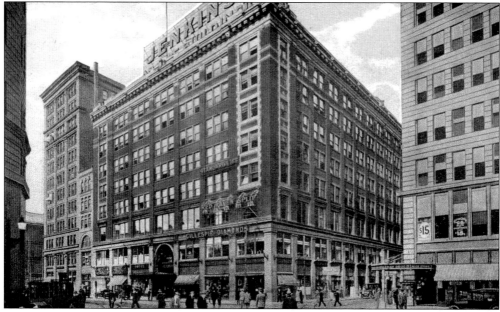

The Jenkins Arcade Building, erected in 1911 and shown here around 1920, was perfectly placed to capture pedestrian traffic moving between the prime retail street in downtown Pittsburgh, Fifth Avenue, and Horne's Department Store on Penn Avenue. The Jenkins Arcade stood at the foot of Fifth Avenue until it was demolished in 1983 and replaced by the Fifth Avenue Place office tower. (JDS.)

The Jenkins Arcade, designed by local architect O. M. Topp, was essentially an interior city street lined with multiple floors of stores in an envelope of classical architecture. It was also a professional office building where many Pittsburghers went to visit their lawyers, accountants, doctors, and dentists.

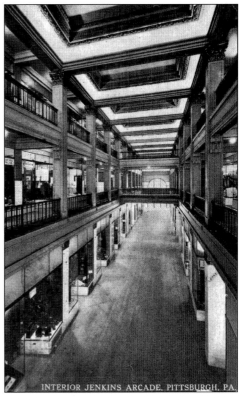

INTERIOR JENKINS ARCADE, PITTSBURGH, PA.

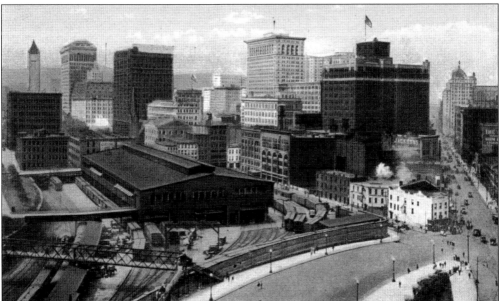

While skyscrapers sprang up in the middle of downtown, the development of the northern part of the Triangle was hindered by the massive freight depot shown in the foreground of this view from Union Station around 1920. Its demolition in 1927 allowed Grant Street (left) to extend to Liberty Avenue (right) and opened up sites for the Koppers and Gulf Buildings and a new U.S. Post Office and Courthouse building.

This view, from the same vantage point, was taken about 10 years after the previous image at a very specific moment: after the completion of the Koppers Building (1929) and before construction of the Gulf Building (1930–1932). Both were constructed under the auspices of the Mellon Bank, whose owners controlled the other two companies. Note the parking lots on the future sites of the U.S. Post Office and Courthouse (left) and Gulf Building (right).

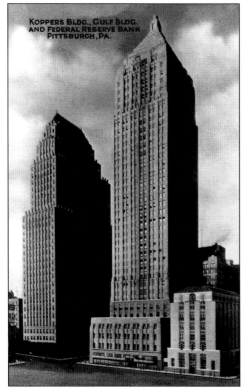

The Koppers, Gulf, and Federal Reserve Bank Buildings are art deco masterpieces built at the beginning of the Great Depression. Architectural elements in common are limestone cladding, setback massing, and extensive art deco ornamentation. The Gulf Building was the tallest in Pittsburgh until it was overtopped by the U.S. Steel Building across Grant Street in 1971.

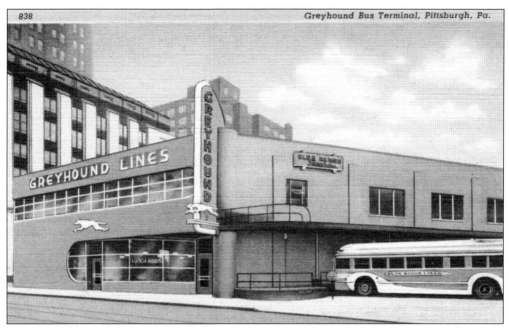

As roads and highways improved across the nation, bus travel developed as an alternative to trains during the 1920s and 1930s. The Greyhound Bus Company established terminals in all major cities in the country. The first Greyhound terminal in Pittsburgh was built on Grant Street next to the Federal Reserve Bank building, seen here on the left in this view taken around 1940, where the current federal building stands. (JH.)

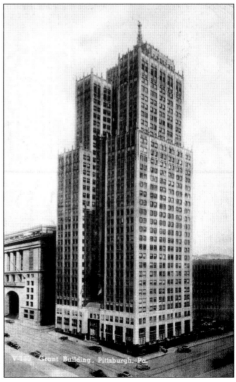

The Grant Building, shown here around 1945, was part of the skyscraper generation of the 1920s. The most modern office building of its day, it was built in 1930 to the design of Henry Hornbostel next to the City-County Building. The tower on top signaled the word *Pittsburgh* in Morse code to alert passing airplanes. Recent remodelings have stripped the building of the ornamentation for which it was known.

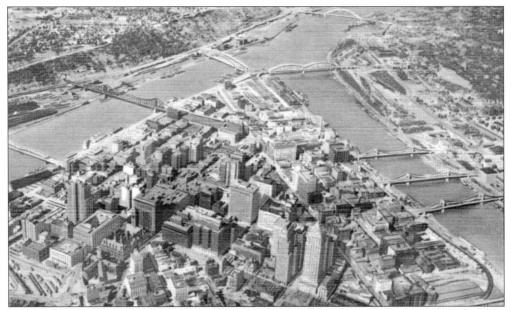

This aerial view of downtown Pittsburgh, taken about 1940, presents a scene both familiar and foreign to modern eyes. The topography and street layout remain virtually unchanged, and many of the buildings remain standing today. However, the once-dominant railroad tracks and yards are no longer apparent; buildings in the Point area and the Lower Hill District have been erased from the map. (JDS.)

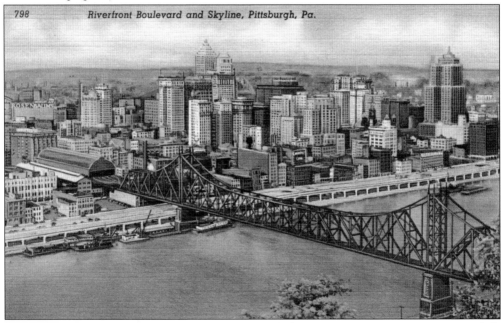

The dramatic decline in river traffic after 1930 and the concomitant increase in automobile traffic led city fathers to transform the Monongahela Wharf into a raised multilane highway with parking underneath before World War II. This postcard from 1945 shows the highway, which would be joined by expressways in the next decade, running under the soon-to-be-demolished Wabash Railroad Bridge.

Three

NORTH OF THE
ALLEGHENY

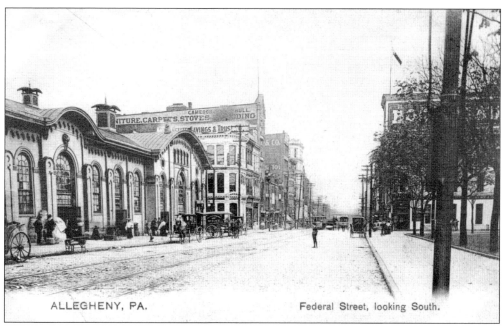

ALLEGHENY, PA. Federal Street, looking South.

During the 19th century, the rich and prosperous city of Allegheny was Pittsburgh's sister city on the north shore of the Allegheny River. The city was laid out with public buildings at the intersection of Federal and Ohio Streets, including the Market House shown in this 1905 view. Federal Street was a primary commercial corridor leading to the river and the bridge that connected the two cities. (JDS.)

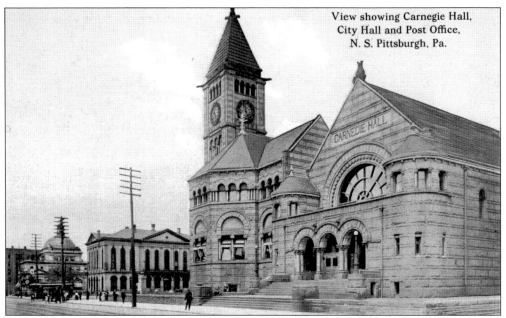

View showing Carnegie Hall,
City Hall and Post Office,
N. S. Pittsburgh, Pa.

The City of Allegheny had a small but complete downtown of its own when it was annexed by the City of Pittsburgh in 1907. This postcard from around 1914 shows three North Side institutions from left to right along Ohio Street: the domed Allegheny Post Office (1897) in the distance, Allegheny City Hall (1884), and the Carnegie Library with its clock tower and music hall (1888).

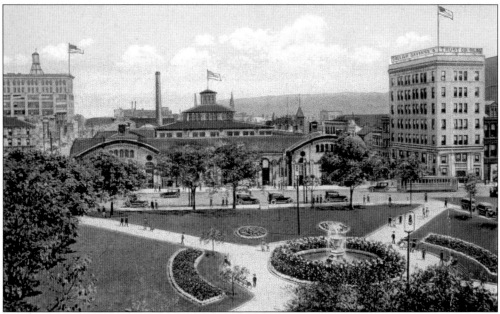

In the early 20th century, the Market House was joined by a new neighbor, the Allegheny branch of Pittsburgh's Dollar Bank, shown here to the right in this 1920s view. The center of town was still well kept and prosperous. On the horizon, however, can be seen new industrial buildings, the harbinger of industrial encroachment inland that eroded the area's amenities and caused its later decline.

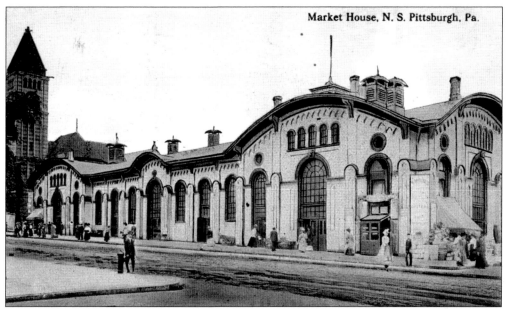

The Market House, shown here in 1912, was the focus of everyday commerce in Allegheny at a time in social history when everyone did their marketing daily. It was designed in a vigorous Romanesque style, dominated by many round-arched windows and doors and strongly detailed brickwork. The top of the pyramidal cupola that lit and vented the large interior space can be seen among the chimneys at the right.

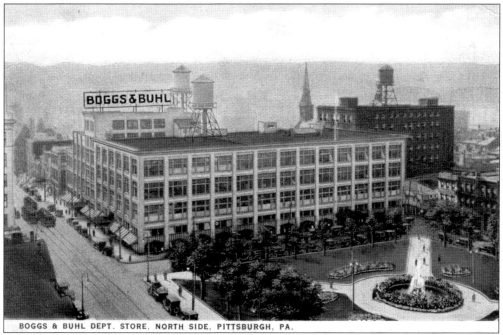

BOGGS & BUHL DEPT. STORE, NORTH SIDE, PITTSBURGH, PA.

This view was taken in the 1920s looking south from the tower of the Carnegie Library and shows Ober Park (Public Square) at lower right and Boggs and Buhl, Allegheny's primary department store. Together with the adjacent Market House (the roof of which can be seen in the lower left corner), Boggs and Buhl constituted the hub of commercial activity in the city.

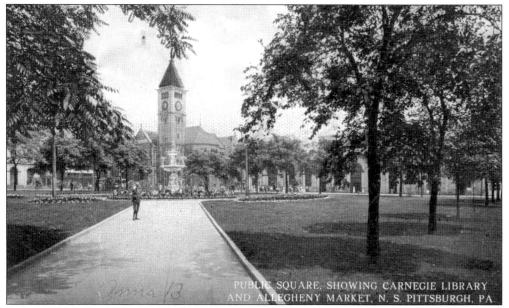

With its flower beds and Victorian fountain, Ober Park (also known as Public Square) provided genteel green space in the midst of Allegheny's urban grid. The Carnegie Library, one of the first donated by steel tycoon Andrew Carnegie, was given to Allegheny because Carnegie grew up there. The library was designed in 1888 by architects Smithmeyer and Peltz, designers of the first Library of Congress building in Washington, D.C. (JDS.)

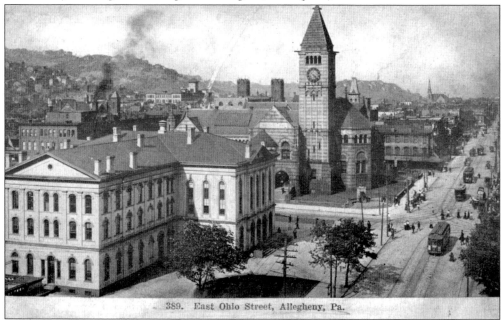

Allegheny's city hall and the Carnegie Library stand on the north side of Ohio Street at its intersection with Federal Street in this 1910 view. Streetcars ply East Ohio Street as it progresses toward Deutschtown, a neighborhood that was the center of German immigration and culture in the Pittsburgh area. The skyline is dominated by church steeples and by the hills that hemmed Allegheny in to the north. (JH.)

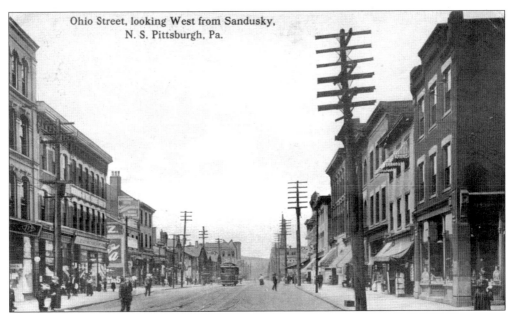

Ohio Street, looking West from Sandusky,
N. S. Pittsburgh, Pa.

This 1910 postcard view was taken on East Ohio Street from a point about two blocks east of Federal Street. The Market House is in the distance just to the left of the streetcar. In this prosperous commercial streetscape, evidence of the increasing use of the telephone can be seen in the telephone poles carrying multiple lines along the street, which is surprisingly free of vehicular traffic. (JDS.)

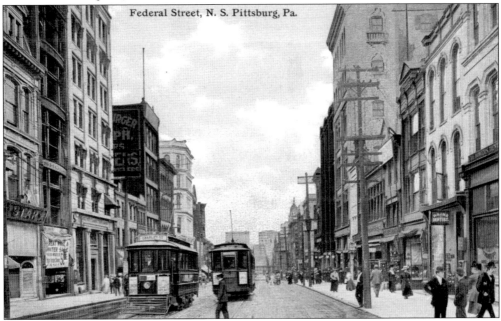

Federal Street, N. S. Pittsburg, Pa.

Federal Street was the main north–south street in Allegheny, running straight from Public Square in the center of town to the Sixth Street Bridge. It developed as a prosperous Main Street commercial district, with buildings in a variety of Victorian architectural styles. Everything shown in this 1911 postcard was demolished in the early 1960s to make way for the construction of Allegheny Center. (JH.)

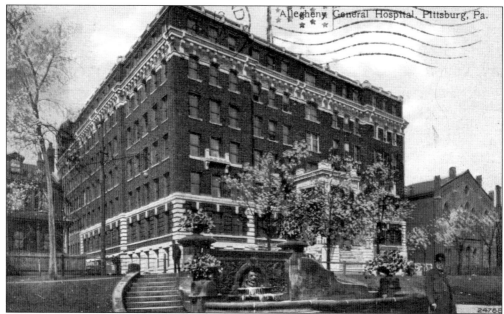

Allegheny General Hospital was founded in two large donated houses in 1886. Outgrowing those quarters by 1904, the hospital moved into its new home along Stockton Street, Allegheny's "second bank," where its neighbors included fine residences and the Second Presbyterian Church (at the far right). The fountain in the foreground adorned a narrow strip of public parkland along Stockton Street. This postcard dates from about 1910. (JDS.)

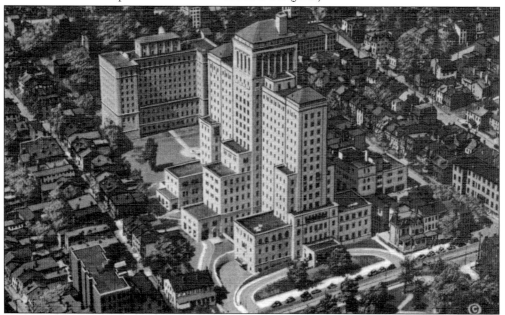

Continued growth of the Allegheny General Hospital led to the abandonment of its second home in favor of the Byzantine/art deco high-rise building that still stands in the residential neighborhood above North Avenue. This aerial view from about 1935 shows the hospital in relation to its surroundings, which included the northeast corner of the Allegheny Commons Park (bottom right). (JDS.)

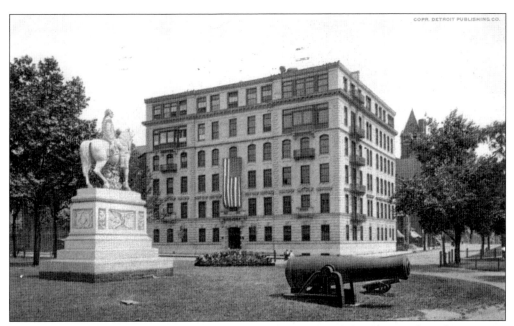

The city of Allegheny owed many of its institutions to the philanthropy of Presbyterians, a dominant religious denomination in 19th-century western Pennsylvania. Presbyterian Hospital was founded in Allegheny in 1893. Shown here in 1915, it stood across North Park from the George Washington monument. The hospital moved to the medical center in Oakland, but the building and the monument still adorn this part of Allegheny Center. (PHLF.)

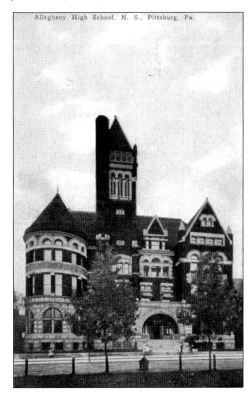

Allegheny High School. N. S., Pittsburg, Pa.

Allegheny High School stood on the east side of West Park, where the Allegheny Middle School currently stands. It was built in 1889 to the design of Pittsburgh architect Frederick Osterling. Osterling utilized the Richardsonian Romanesque style of the Allegheny County Courthouse, including rough masonry, round arches, and corner turrets. The tower, similar to that of the courthouse, emphasizes the importance of the high school as a public building. (JDS.)

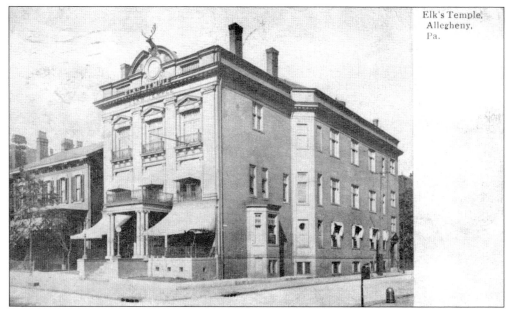

The late 19th and early 20th centuries were the halcyon period for fraternal organizations in the United States, and Pittsburgh was home to many such groups. This 1905 postcard shows the Elks' Temple of Allegheny, located among the fine houses along Cedar Avenue at Washington (now Pressley) Street in the Deutschtown neighborhood. To eliminate any doubt about its purpose, the building sports an elk's head at its roofline. (JDS.)

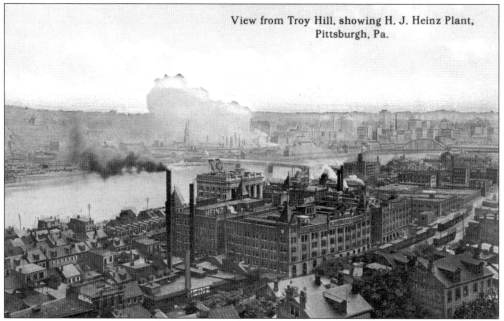

View from Troy Hill, showing H. J. Heinz Plant, Pittsburgh, Pa.

The H. J. Heinz food-processing plant, shown in this 1910 view from Troy Hill, was one of the principal employers in the German neighborhood in which it stood. Many Heinz employees lived in the row houses along River Avenue. The Heinz plant eventually expanded and took over the rest of the neighborhood. Across the river, smoke from heavy industry in the Strip District can be seen.

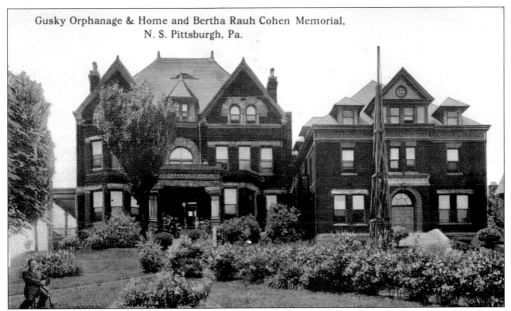

Gusky Orphanage & Home and Bertha Rauh Cohen Memorial,
N. S. Pittsburgh, Pa.

Institutions little seen today figured prominently in the life of Victorian-era Pittsburgh. Among these were orphanages founded by philanthropists, churches, and ethnic organizations. The Gusky Orphanage was founded in 1890 by Esther Gusky in honor of her husband to provide a home for Jewish orphans. The institution flourished for many years at the corner of Perrysville and Riverview Avenues; the site is now part of the Byzantine Catholic Seminary.

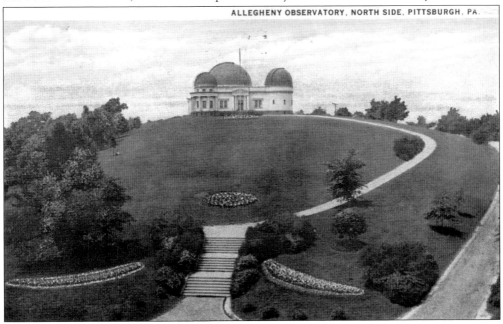

ALLEGHENY OBSERVATORY, NORTH SIDE, PITTSBURGH, PA.

The three-domed Allegheny Observatory, built in 1900 to the design of architect Thorsten Billquist, stands atop the tallest hill on the North Side in Riverview Park. Owned by the University of Pittsburgh, it is the successor to an earlier observatory that was located on the Perry Hilltop campus of the Western University of Pennsylvania. John Brashear, a famous director of the observatory, is interred in a crypt under the main telescope. (JDS.)

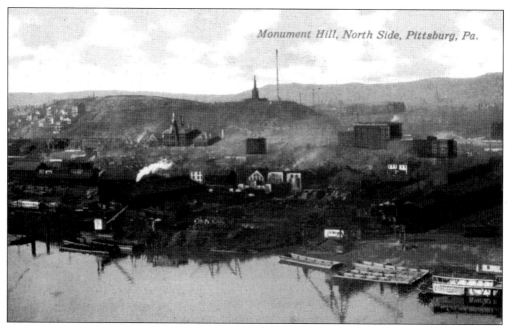

Atop Monument Hill stands the Soldiers' Memorial, erected in 1871 by the citizens of Allegheny to honor their Civil War dead. Below it on the left is the First Ward Public School; to the right, the tall building is the Phipps Apartments, a philanthropic venture of steelman Henry Phipps. Highways, Heinz Field, and parking lots now occupy the area shown in this view from around 1916.

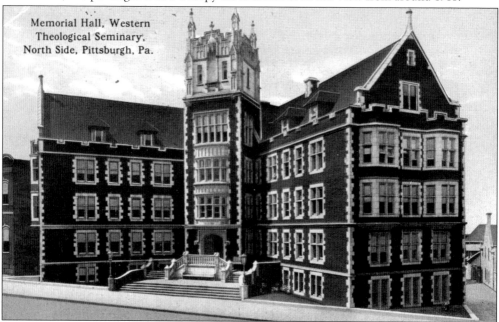

Memorial Hall, Western Theological Seminary, North Side, Pittsburgh, Pa.

Western Theological Seminary, founded by the Presbyterian Church in 1825, was the second seminary west of the Allegheny Mountains. Memorial Hall was built in 1912 in the Jacobethan style, which was considered formal and impressive enough to stand on Ridge Avenue among the fine houses of Allegheny's millionaires' row. It is now a classroom building of the Community College of Allegheny County. (JDS.)

44

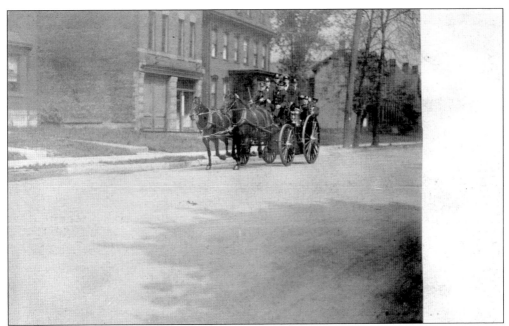

The pride of the Allegheny Fire Department drives a fire engine along a North Side street in this real–photo postcard from around 1910. Just a few years later, the fire department began to replace its horse-drawn apparatus with fire trucks. This view may have been taken on North Avenue. (JDS.)

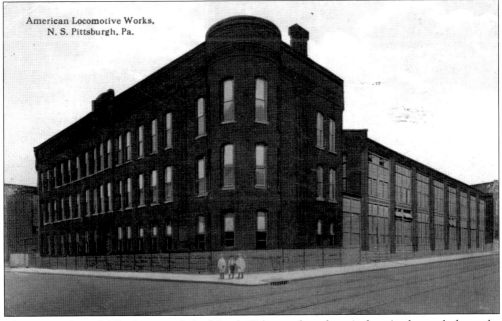

The prosperity of Allegheny and the North Side was based on industries located along the Allegheny River and especially on the Ohio River shore. The American Locomotive Works, shown here in 1915, was located in Manchester on Seymour Street. This plant was originally founded as the Pittsburgh Locomotive Works in 1862 by Andrew Carnegie. It closed in 1919 and was razed. (JH.)

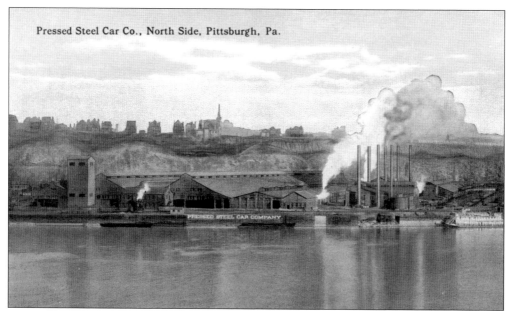

Pressed Steel Car Co., North Side, Pittsburgh, Pa.

At its height, the Pressed Steel Car Company was the largest manufacturer of railroad cars in the United States. The plant, shown here in a 1916 postcard, was located on the Ohio River at Woods Run in Allegheny. It stood north of the penitentiary and the American Standard plumbing fixture factory, which dominated the Ohio River bank of the North Side for many years. (JDS.)

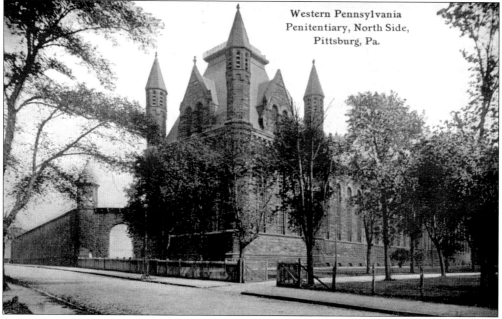

Western Pennsylvania Penitentiary, North Side, Pittsburg, Pa.

Pennsylvania's prison system originally consisted of the Eastern Penitentiary in Philadelphia and the Western Penitentiary in Allegheny. The first Western Penitentiary building (where the National Aviary stands today) was completed in 1826. It was replaced in 1882 by a larger facility along the Ohio River, shown in this postcard from about 1910. The Romanesque Revival prison, site of major riots in 1921 and 1953, operated on this site until 2005.

Four

SOUTH OF THE MONONGAHELA

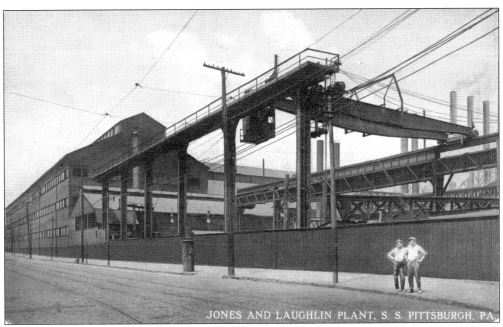

JONES AND LAUGHLIN PLANT, S. S. PITTSBURGH, PA.

The first settlements south of the Monongahela River were bucolic farms, but towns soon were founded, including Birmingham and East Birmingham, whose names echoed with the hope that industry would soon follow. And so it did. The South Side eventually became a mill town built around glass, iron, and steel factories. Jones and Laughlin Steel's South Side Works dominated the area for a century until it shut down in 1983. (PHLF.)

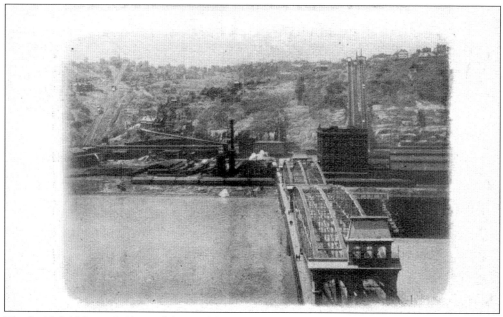

The Smithfield Street Bridge and the neighboring inclines were perennial subjects for photographers. The Castle Shannon Incline on the left and the Monongahela Incline on the right can be seen in this view dating from about 1905. Pittsburgh had a total of two dozen such cable-driven funiculars in all, providing easy transit from industrial valleys to residential hilltops; today only two, including the Mon Incline, remain in service. (JDS.)

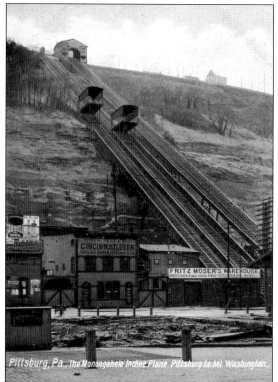

The Monongahela Incline was the first passenger incline in Pittsburgh, built in 1870 from the foot of Smithfield Street to the top of Mount Washington. The engineer was Samuel Diescher, who was responsible for most of Pittsburgh's inclines. From 1884 until 1935, a second, larger freight incline operated next to the passenger incline. Two freight incline cars and the upper passenger station can be seen in this 1905 postcard view.

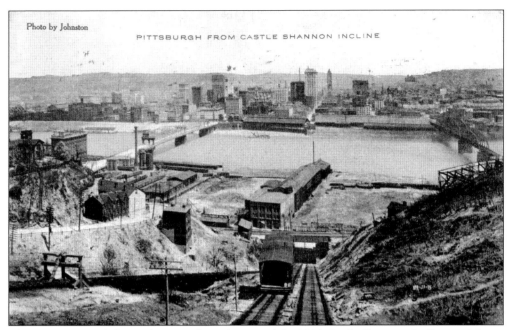

PITTSBURGH FROM CASTLE SHANNON INCLINE

This 1906 postcard shows the view from the top of the 1890 Castle Shannon Incline on Mount Washington. The Pittsburgh and Lake Erie Railroad complex is on the left, and the Baltimore and Ohio Railroad station can be seen at the far end of the Smithfield Street Bridge. The Panhandle Bridge, still in use today by the light rail system, is at the far right. This incline was dismantled in 1964.

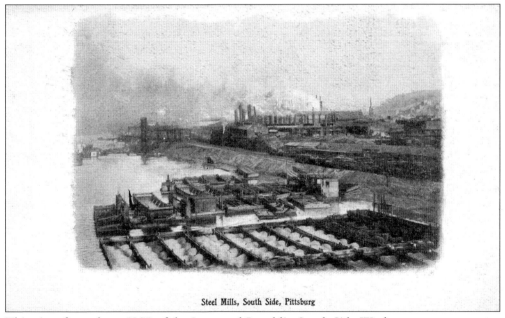

Steel Mills, South Side, Pittsburg

This view from about 1905 of the Jones and Laughlin South Side Works conveys some sense of the immense size of the steel mill that came to dominate life on the South Side—and some idea of the contribution that it made to the city's legendary air pollution. In the foreground are barges on the Monongahela River, lined up and waiting to feed raw materials into the furnaces of the plant.

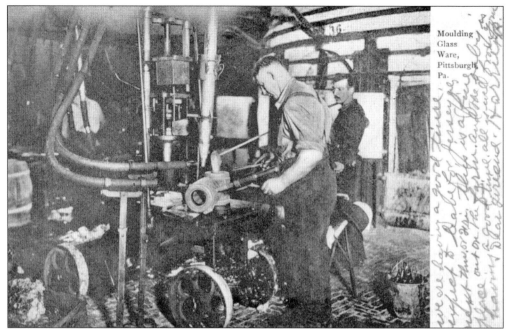

Pittsburgh was the nation's largest producer of glass in the early 20th century. An enormous variety of wares were made in South Side glasshouses. In this 1910 postcard, one workman is pouring molten glass (taken from the furnace in the background) into a mold held by the other workman, who will close the mold to form a piece of tableware. (HHC.)

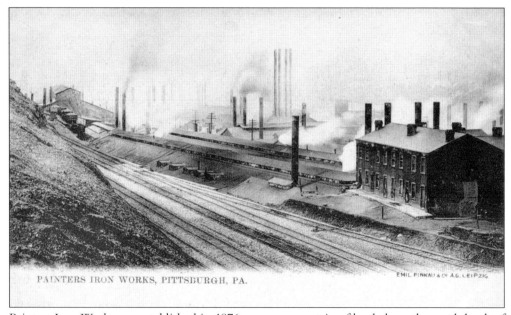

Painters Iron Works was established in 1876 on a narrow strip of land along the south bank of the Ohio River, just downstream from the Point. A notoriously unhealthy set of dwellings, called Painters Row, was built to house some of the plant's laborers. Some of them can be seen on the right in this 1910 postcard. An office/warehouse structure called Gateway View Plaza now stands on this site. (HHC.)

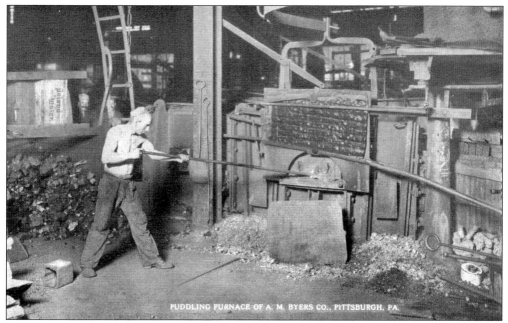

The A. M. Byers wrought iron mill utilized large open hearths and small "puddling furnaces" to melt and refine pig iron into wrought iron. Part of this refining process included stirring the melted iron, which was done by a puddler with a long iron rod, shown here in this 1916 postcard. Note the absence of any kind of safety equipment for this worker. (JDS.)

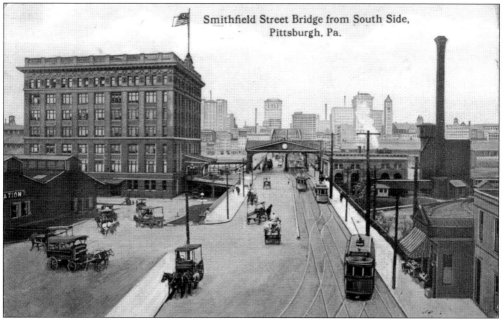

This view of the south end of the Smithfield Street Bridge shows the Pittsburgh and Lake Erie Railroad station and the crowded, bustling, industrial character of its surroundings in 1914. The Pittsburgh and Lake Erie freight terminal is on the far left; its offices and waiting room are in the large building behind (both now part of Station Square). A streetcar shelter can be seen just in front of the bridge.

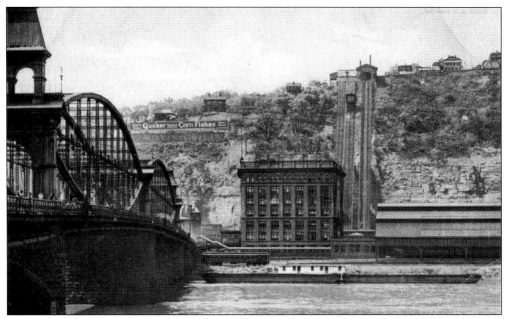

In this 1908 view of the South Side from the Monongahela Wharf, the Monongahela Incline can be seen in the gap between the headhouse and the train shed of the Pittsburgh and Lake Erie Railroad station. Now known as Station Square, the Pittsburgh and Lake Erie complex houses offices, restaurants, and shops. The scrubby slopes of Mount Washington were used, then as now, as advertising space. (CLP.)

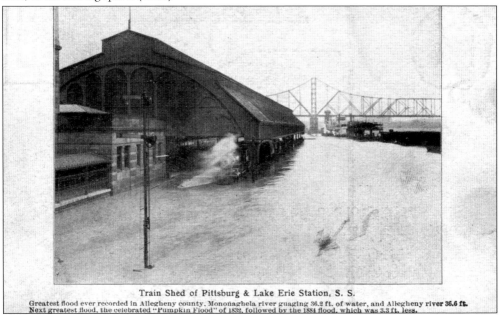

Train Shed of Pittsburg & Lake Erie Station, S. S.
Greatest flood ever recorded in Allegheny county. Monongahela river guaging 36.2 ft. of water, and Allegheny river 35.6 ft. Next greatest flood, the celebrated "Pumpkin Flood" of 1832, followed by the 1884 flood, which was 3.3 ft. less.

The 1907 flood was, at the time, the greatest in recorded history in Pittsburgh and has only been surpassed by the St. Patrick's Day flood of 1936. Here the waters of the Monongahela River have swamped the train shed of the Pittsburgh and Lake Erie Railroad station. A stranded locomotive emits steam in the train shed. The Wabash Railroad Bridge can be seen in the distance. (PHLF.)

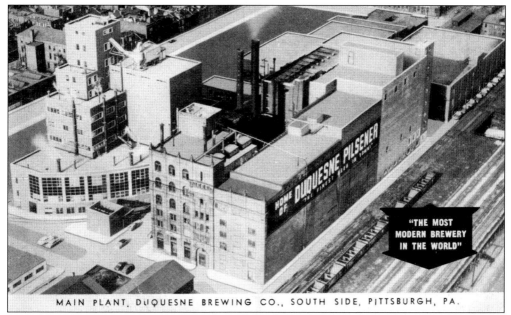

MAIN PLANT, DUQUESNE BREWING CO., SOUTH SIDE, PITTSBURGH, PA.

The Duquesne Brewery at South Twentieth and Mary Streets was one of several large breweries in Pittsburgh. The complex was assembled over four decades, as can be seen in this 1940 view, and was best known for the large advertising clock in its main tower. The brewery closed in 1972; its buildings are now home to the Brew House Association, which provides housing and studio space for artists. (HHC.)

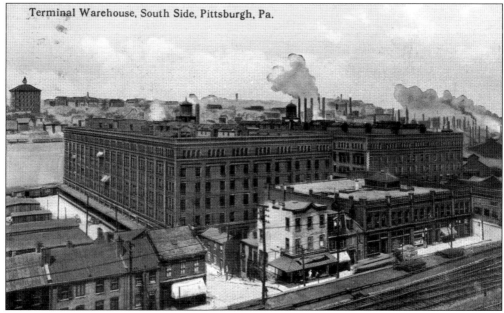

Terminal Warehouse, South Side, Pittsburgh, Pa.

As a center of heavy industry, Pittsburgh never developed the extensive redbrick warehouse districts characteristic of cities that were more engaged in the shipping and storage of manufactured goods. However, Pittsburgh had several warehouse complexes, including the Terminal Warehouse on East Carson Street, shown here in 1913. Built in 1900, it is now in use as an office building. Duquesne University can be seen on the bluff across the river. (JDS.)

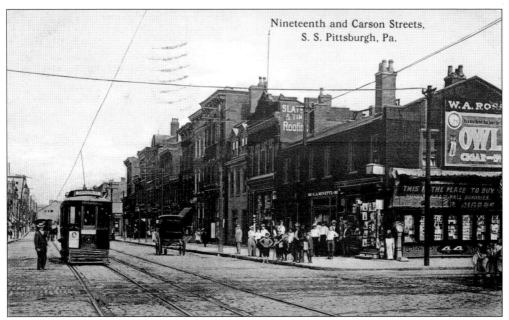

East Carson Street developed over the years into the principal commercial street on the South Side, forming a continuous row of storefront buildings and banks from South Tenth Street to the Jones and Laughlin plant at South Twenty-fourth Street—over a mile of Victorian streetscape. This 1910 postcard view shows a typical section of Carson Street from the corner of South Nineteenth Street looking east toward the steel mill. (HHC.)

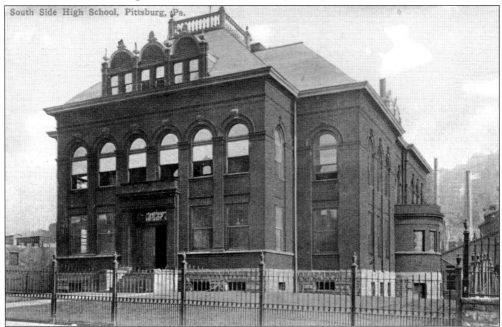

South Side High School at East Carson and South Tenth Streets was constructed in 1897 in the Renaissance Classical style and is shown here before it was greatly enlarged in 1923. The school had a strong vocational training component from the beginning, not surprising in a community so dominated by industry (note the smokestacks in the background). (PHLF.)

54

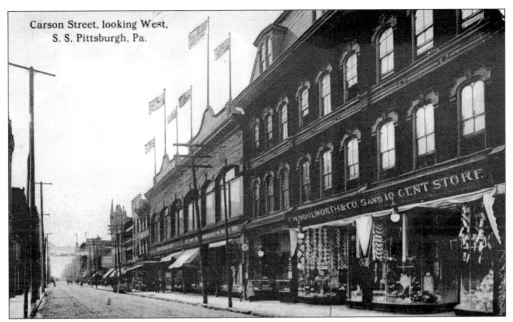

Carson Street, looking West,
S. S. Pittsburgh, Pa.

This view from about 1917 of East Carson Street, looking west from South Fourteenth Street, shows another typical block in the South Side commercial district. The building on the right, dating from the 1870s, houses a Woolworth's, an early national chain store. Tall windows on the second floor of the neighboring building suggest that it was meeting hall for one of numerous fraternal organizations then in existence. (HHC.)

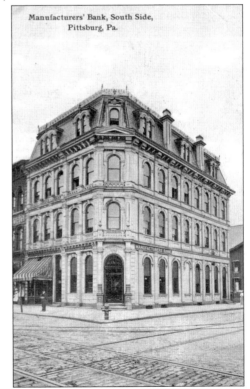

Manufacturers' Bank, South Side,
Pittsburg, Pa.

The names of banks on the South Side reflected the importance of industry to the local economy, including the Iron and Glass Bank and here the Manufacturer's Bank in a 1913 view. This early-1870s building, which still stands at 1739 East Carson Street, was built in the mansarded Second Empire style with a cast-iron facade, a product of the post–Civil War flush of prosperity in the neighborhood. (JDS.)

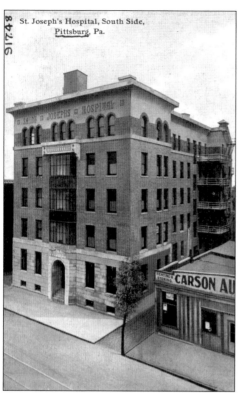

St. Joseph's Hospital, South Side,
Pittsburg, Pa.

In the early 20th century, the commercial character of Carson Street began to change somewhat, as new institutions and businesses squeezed into its crowded blocks. Two of these can be seen in this postcard view: St. Joseph's Hospital (1911) and an automobile garage. St. Joseph's later expanded into the site of the garage; it is now a residence for the elderly called Carson Towers. (CLP.)

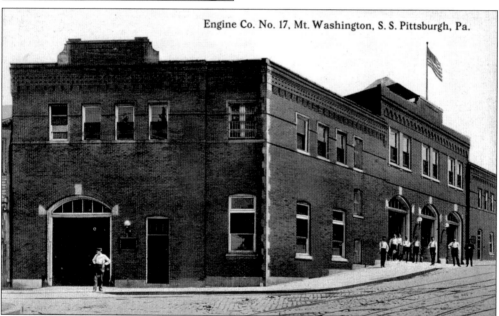

Engine Co. No. 17, Mt. Washington, S. S. Pittsburgh, Pa.

Fire stations are often one of a neighborhood's principal landmarks, and this one on Mount Washington at the top of Virginia Avenue is no exception. The firehouse is still standing and in operation although not quite as shown in this 1910 postcard view. The building in the foreground has been torn down; the arched doorway was retained to serve as a gateway to the park that now occupies the site.

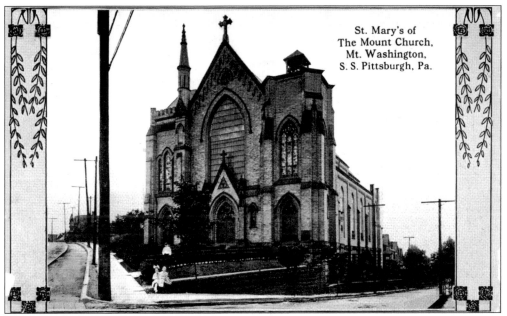

St. Mary on the Mount (1893) was the first Catholic church on Mount Washington, founded in 1871 as a mission of St. Malachy's Church on the flats below (located where Station Square is now). The church was built out of yellow brick in the Gothic Revival style. Seen here in 1920, St. Mary's is still a vibrant parish church. A bell tower was added to the building in 1999. (HHC.)

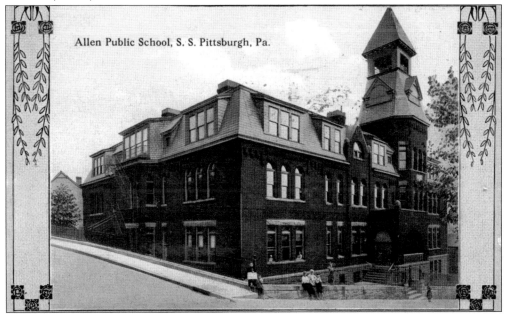

The Allen Public School, shown here in a 1915 postcard, was located at the corner of Allen Avenue and Excelsior Street in the Allentown neighborhood on Mount Washington. It was built in the 1890s in a mix of Richardsonian Romanesque and Queen Anne styles. The central bell tower proclaimed the building's important public purpose. This site is now a parking lot for an adjacent senior citizens apartment building. (HHC.)

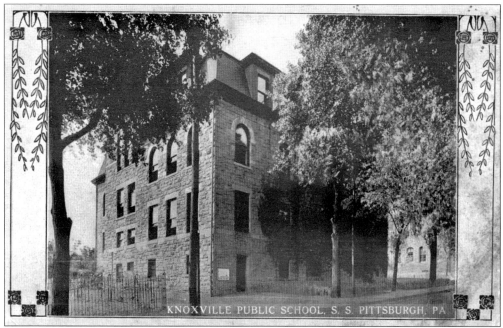

The 1890s Knoxville Public School was built in a version of the Richardsonian Romanesque style that swept over Pittsburgh after the completion of the county courthouse in 1888. The building still stands at the corner of Knox Avenue and Rochelle Street, although it is significantly altered and now used as a apartment building. This postcard dates from about 1913. (HHC.)

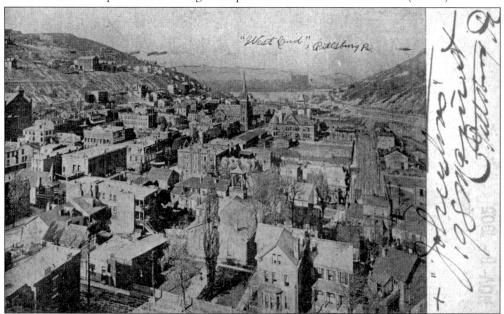

The West End neighborhood, seen here about 1898, nestles in the valley cut by Saw Mill Run through Mount Washington across from the Point. Originally called Temperanceville, the densely built and diverse community has been isolated and defined by steep surrounding hillsides. The West End had a front-row seat when the gigantic gas tank visible on the north side of the Ohio River exploded in 1927. (HHC.)

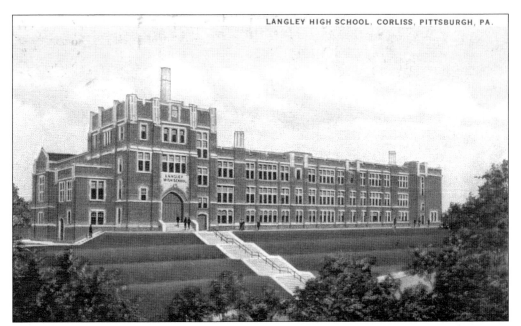

The 1923 Langley High School was newly built in the Sheraden neighborhood (above the West End) when it was featured in this postcard. It was designed in the Tudor Revival style by architects MacClure and Spahr, who worked in the same style at the Oliver Bath House and the Jones and Laughlin Building. Langley still operates as a high school in the Pittsburgh public school system. (HHC.)

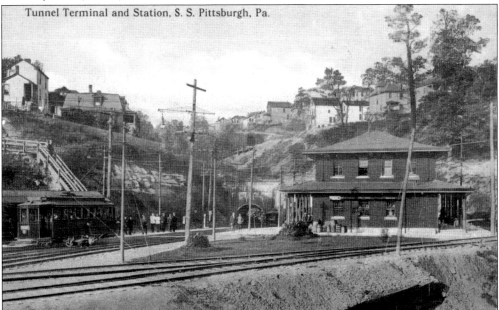

Tunnel Terminal and Station, S. S. Pittsburgh, Pa.

In 1904, the Pittsburgh Railways Company constructed the South Hills Tunnel through Mount Washington for its electric streetcars. From the south end of the tunnel, called South Hills Junction, the streetcar lines were extended out along the ridges and spurred development of streetcar suburbs, including Beechview, Carrick, Overbrook, and Brookline, all soon annexed by the City of Pittsburgh. This postcard dates from about 1915. (CLP.)

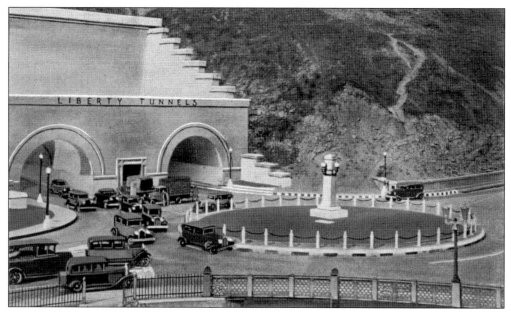

Cars emerging from the north end of the Liberty Tunnels had to merge with traffic coming from the South Side Flats and Mount Washington before crossing the Liberty Bridge into downtown. As this postcard from about 1935 shows, the first device for controlling the flow was a traffic circle with ornamental plantings. This note of civic grace soon succumbed to the heavy volume of traffic. (JH.)

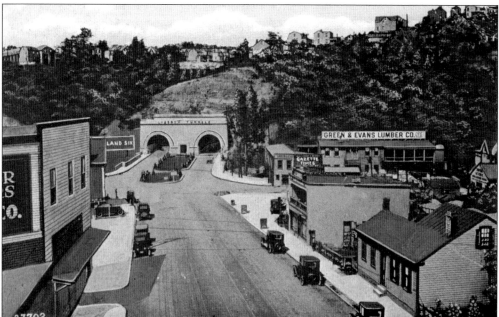

When the Liberty Tunnels were being planned, there was debate about where the south end should emerge from Mount Washington—higher, to benefit the existing hillside neighborhoods, or lower, to provide a fast route for automobiles to reach the suburbs of Brookline, Dormont, and Mount Lebanon. The lower route was chosen, and the opening of the tunnels in 1924 sparked new development along West Liberty Avenue and Washington Road. (JDS.)

Five

EAST OF THE TRIANGLE

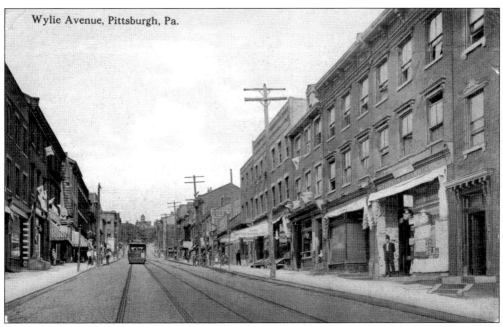

Wylie Avenue, Pittsburgh, Pa.

After the Civil War, the city expanded up and over the broad hill east of the Golden Triangle. The neighborhood became known as the Hill District, and Wylie Avenue was its principal commercial street. This 1907 postcard shows a typical block in the Lower Hill District, an area that was a first stop for many immigrants. The tall building on the horizon was a public school (now demolished). (JDS.)

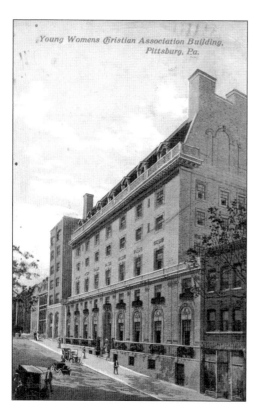

Owing to its proximity to downtown, the Lower Hill District was home to a number of important institutions. In 1909, the Young Women's Christian Association built this impressive structure on Chatham Street. It served as a home for many single young women who had begun to move into the downtown job market as retail and office workers. This building was demolished during the Lower Hill Urban Renewal Project in the 1960s. (JDS.)

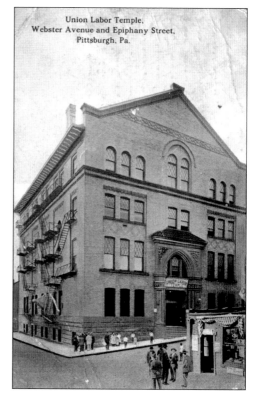

This building, erected in 1902, was the first Syria Mosque of the Pittsburgh Shriners. After the Shriners moved to Oakland, several labor unions purchased the building in 1910 and converted it into the Union Labor Temple, containing shared office and meeting spaces. By 1924, the building had become the Home for the Improvement of the Poor. It too was demolished during urban renewal.

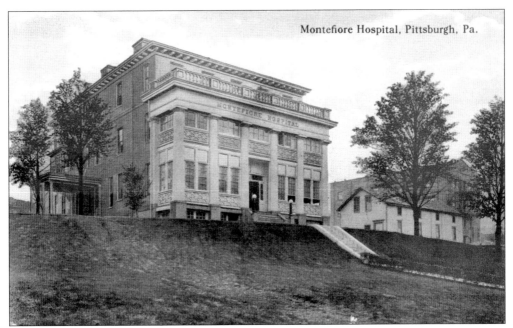

Montefiore Hospital, Pittsburgh, Pa.

Montefiore Hospital was founded in 1908 in a large donated house on Centre Avenue in the Upper Hill District (seen here in 1916). Named after the famous 19th-century British philanthropist Moses Montefiore, it was intended to serve the Jewish immigrant population of the Hill. Montefiore Hospital relocated to the Oakland hospital complex in 1927.

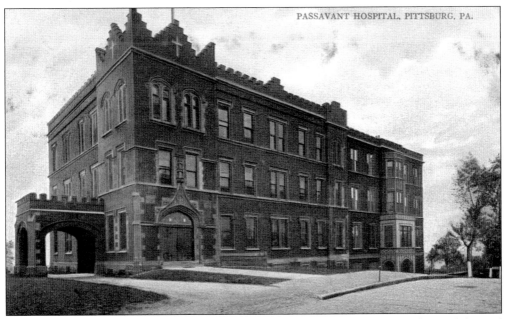

PASSAVANT HOSPITAL, PITTSBURG, PA.

Dr. W. A. Passavant founded Passavant Hospital in 1849 as a Protestant charity hospital, located in the Lower Hill District at the corner of Roberts and Reed Streets. The Tudor-style building shown in this 1908 postcard was constructed in 1895 to accommodate the hospital's growth. Passavant Hospital relocated to the northern suburbs of Pittsburgh in the mid-1960s, and this building was demolished. (CLP.)

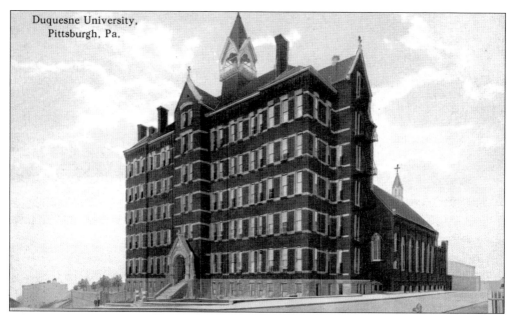

Duquesne University was founded in 1878 as the Catholic College of the Holy Spirit. Old Main, its first building, was constructed in 1885 atop the bluff that overlooks both downtown Pittsburgh and the Monongahela River. Old Main and the university chapel are shown in a postcard view of 1911, the year the school was renamed Duquesne University. Old Main now serves as the university's administrative building.

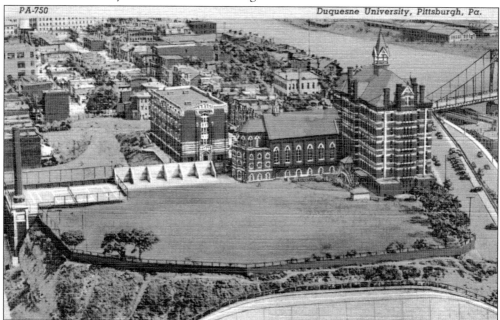

Old Main, the chapel, and Canevin Hall (1922) can be seen in this 1944 aerial view of the Duquesne University campus. Occupying 12 acres at the time, Duquesne has in recent decades expanded its campus to 48 acres with 31 buildings, displacing the residential Bluff neighborhood that can be seen here between Duquesne and Mercy Hospital. These three oldest buildings at Duquesne are still in use today.

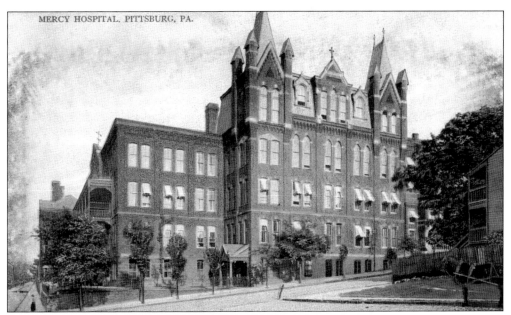

MERCY HOSPITAL, PITTSBURG, PA.

Mercy Hospital was the first hospital in Pittsburgh, founded in 1847 by the Catholic Sisters of Mercy just two years after the great fire. Located on the bluff above the Monongahela River, the building shown in this 1908 postcard was erected in 1885. Its tall, attenuated Gothic Revival central pavilion is flanked by wings fronted by lacy, cast-iron balconies. This building was demolished during a later hospital expansion. (CLP.)

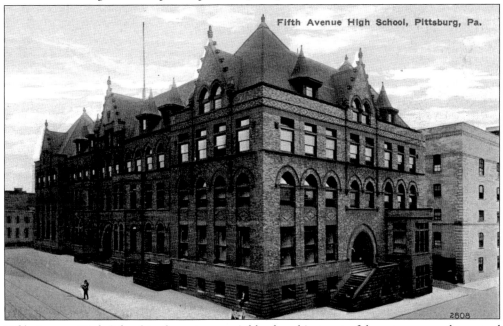

Fifth Avenue High School in the uptown neighborhood just east of downtown was the second high school in Pittsburgh, built in 1894 to meet a growing need for secondary and business education. Its young architect, Edward Stotz, later designed the rival Schenley High School in Oakland. The high school was closed in 1976. The building, seen here around 1912, is still an impressive landmark although no longer in use.

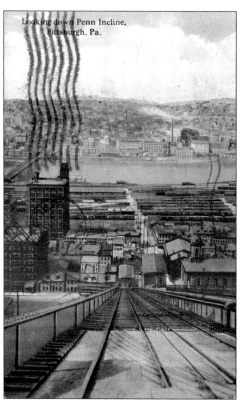

In 1883, a large incline was built to connect the Hill District to the Strip District at Penn Avenue and Seventeenth Street. At the time of this 1916 view, the city's wholesale produce market had been relocated to the rail yard visible in the distance. Hill District vendors used the incline to fetch produce that they could sell from their carts. Declining use caused the closure of this incline in 1958.

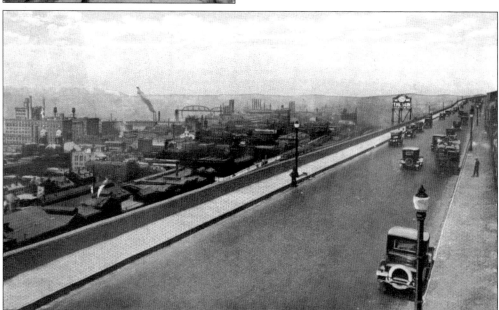

Bigelow Boulevard was built in the late 19th century as a fast carriage road between downtown and the burgeoning East End. By the time of this 1930s postcard, it had become an automobile commuting route, bypassing the congested Strip District below but providing a panoramic view of industry in the Allegheny valley. Visible are the Armstrong Cork Factory on the left and the Union steel mill in the distance. (JH.)

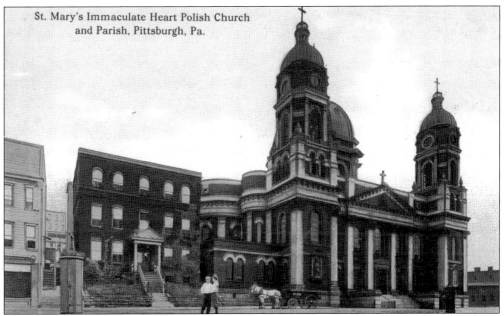

St. Mary's Immaculate Heart Polish Church
and Parish, Pittsburgh, Pa.

In the late 19th century, Pittsburgh's immigrant Polish community was precariously established on the side of the hill, overlooking the mills of the Strip District where many of them worked. The centerpiece of Polish Hill was the Immaculate Heart of Mary Church on Brereton Street, built in 1904 and seen here shortly thereafter. Known for its highly visible copper dome, the church remains the Polish cultural center in Pittsburgh. (PHLF.)

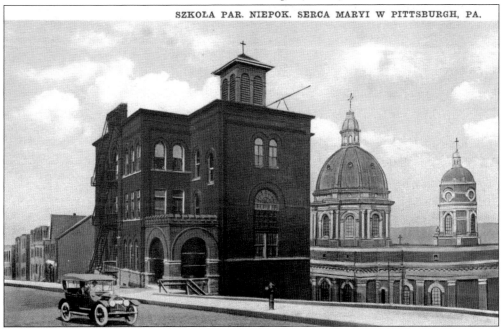

SZKOŁA PAR. NIEPOK. SERCA MARYI W PITTSBURGH, PA.

The immigrant families on Polish Hill who built the Immaculate Heart of Mary Church also built a parochial school just uphill to maintain and promote their religion and ethnic heritage. The school building, perched on Paulowna Street, was added to in later years but now stands vacant. This view dates from the 1920s. (HHC.)

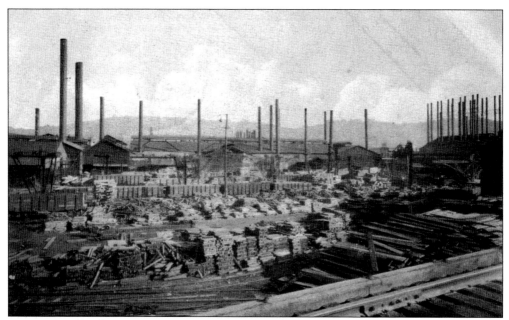

Andrew Carnegie's first venture in steelmaking began in Pittsburgh's Strip District during the Civil War. He founded one firm and purchased another in 1865 to form the Union Iron Mill Company, which specialized in the production of rails for railroads. The Lower and Upper Union Mills, seen here about 1905, stretched along the Lawrenceville riverfront from Twenty-eighth to Thirty-third Streets. Steel production at this site continued until 1990. (PHLF.)

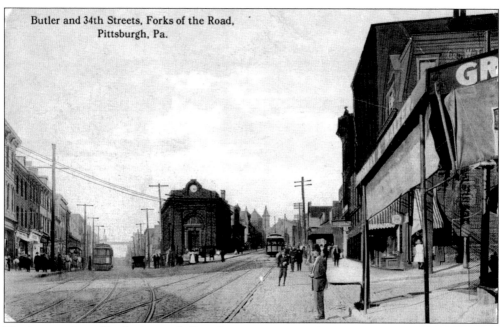

The intersection of Butler Street (left) and Penn Avenue (right) has been an important junction in the Lower Lawrenceville neighborhood for more than a century. The Pennsylvania National Bank (1900) occupies the triangular wedge of land between the streets in this postcard view from 1910. The towers of St. Augustine Church are visible in the distance.

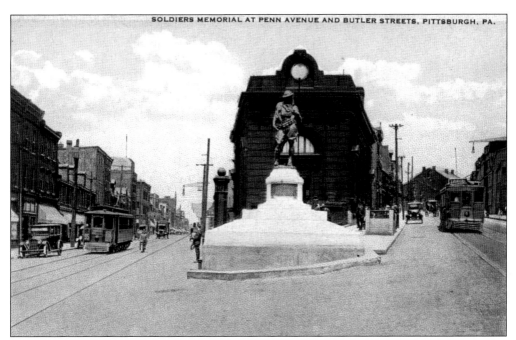

This is a view of the same intersection in the mid–1920s. A war memorial statue by sculptor Allen Newman, called *Doughboy* in honor of American veterans of World War I, was erected in front of the bank building in 1921. The statue is a beloved landmark and symbol of Lawrenceville and has given its name to Doughboy Square. (HHC.)

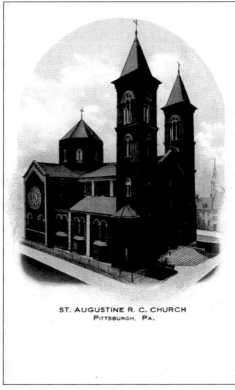

ST. AUGUSTINE R. C. CHURCH
PITTSBURGH, PA.

St. Augustine was a German Catholic parish founded in Lawrenceville at the time of the Civil War. After its first church was built in 1866, the parish was placed under the jurisdiction of Capuchin Fathers who had been expelled from Germany in 1873. The current church building, shown in this postcard view from about 1920, was built in 1901 to the design of architect John T. Comes. (HHC.)

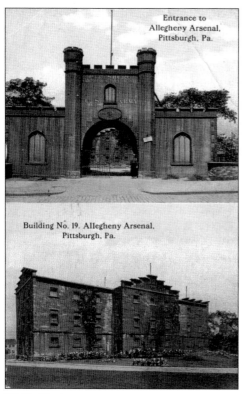

Entrance to Allegheny Arsenal, Pittsburgh, Pa.

Building No. 19. Allegheny Arsenal, Pittsburgh, Pa.

Established in 1814, the Allegheny Arsenal transformed the Lawrenceville neighborhood into an industrial center. Its walls flanked both sides of Butler Street between Thirty-ninth and Fortieth Streets, from the river up the hill to Penn Avenue. The upper part of the arsenal ground is now the site of a park and middle school; the lower part was cleared in 1926 and is now covered by warehouses. (HHC.)

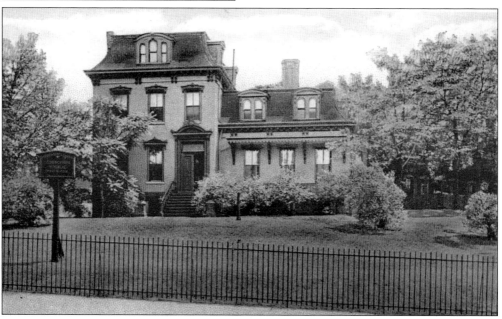

This 1870s Second Empire–style house on Penn Avenue is significant because it occupies the site of the house in which Stephen C. Foster, the great American songwriter and composer, was born on July 4, 1826. His father, William Foster, was a founder and mayor of the community of Lawrenceville before it was annexed by the City of Pittsburgh. This house, nicely restored, is now an apartment building. (HHC.)

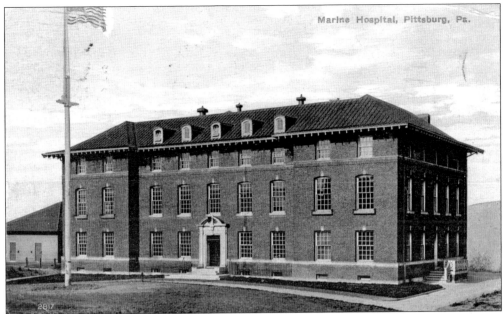

In 1900, the federal government established the U.S. Marine Hospital on Penn Avenue at the top of the arsenal property. This building was designed in the Colonial Revival style with arts and crafts elements. The building at left is an old arsenal storage structure. The hospital complex was eventually shut down, and the building is now occupied by the Allegheny County Health Department. (PHLF.)

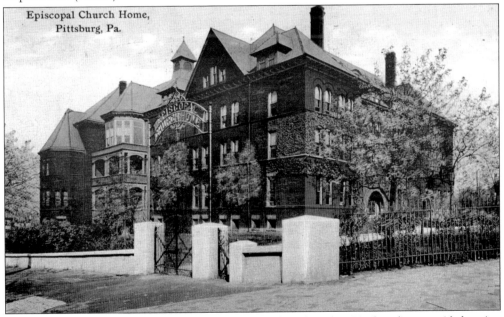

The Episcopal Church Home, founded 1859, was the first charity in Pittsburgh to provide housing for the elderly (although for years after the Civil War it also provided refuge for war orphans). This 1893 Romanesque-style building, located at Penn Avenue and Fortieth Street, has been subsumed by additions made since World War II. The complex is now called Canterbury Place. This postcard dates from 1905. (HHC.)

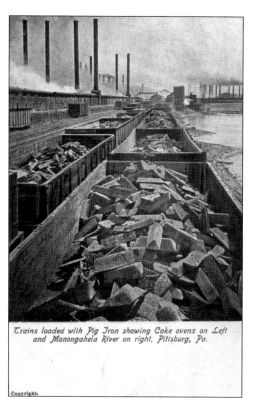

Trains loaded with Pig Iron showing Coke ovens on Left and Monongahela River on right, Pittsburg, Pa.

Copyright.

Jones and Laughlin Steel lined the north bank of the Monongahela River opposite its South Side Works with additional facilities and built a large coke plant in once-bucolic Hazelwood. This postcard view from about 1910 illustrates the heavily industrial nature of the area.

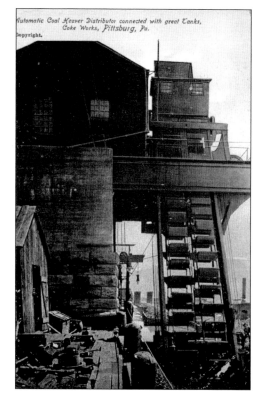

Automatic Coal Heaver Distributor connected with great Tanks, Coke Works, Pittsburg, Pa.

Copyright.

The machine depicted in this 1910 postcard was part of the coke works built by Jones and Laughlin Steel along the Monongahela River in Hazelwood. Coal was baked in ovens to burn off its volatile components and make a more efficient fuel for the iron–smelting and steelmaking processes. The coke works in Hazelwood closed in the late 1990s. (HHC.)

Six

OAKLAND

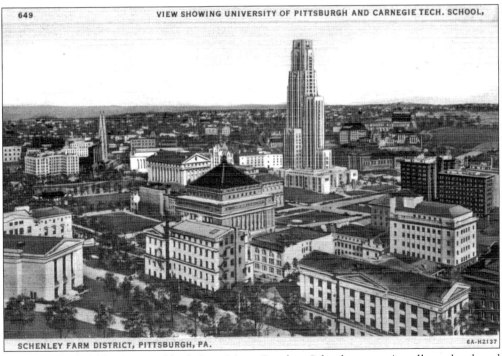

The center of Oakland, owned by heiress Mary Croghan Schenley, was virtually undeveloped at the time of her death in 1903. Twenty years later, through the coordinated efforts of leading citizens and institutions, Oakland became the seat of education, culture, and society in Pittsburgh. This postcard view from about 1940 of the Oakland Civic Center is dominated by the University of Pittsburgh's Cathedral of Learning.

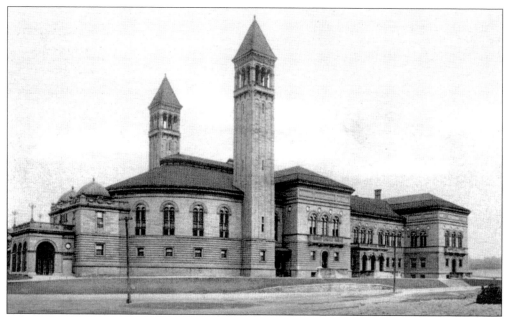

Andrew Carnegie led the migration of civic institutions to Oakland by pledging to give a major library and museum complex to the City of Pittsburgh, shown here around 1900. The rounded, French-inspired Music Hall, which faced Forbes Avenue, is to the left of the towers; the library and museums are to the right. The museum and library complex, completed in 1895, was immediately popular.

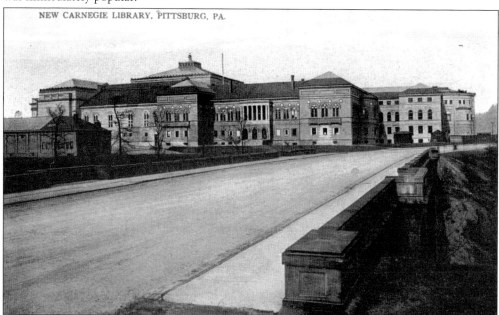

NEW CARNEGIE LIBRARY, PITTSBURG, PA.

The popular success of his library and museums inspired Carnegie to quadruple the size of the complex by 1907. The towers were removed, and the building was enlarged and wrapped in an elaborate Beaux-Arts envelope by architects Alden and Harlow. In this view from 1907, the additions and infilled stonework can be seen as lighter, cleaner stone against the darkened stone of the original section.

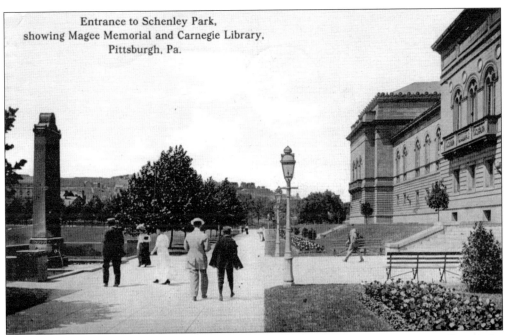

Entrance to Schenley Park,
showing Magee Memorial and Carnegie Library,
Pittsburgh, Pa.

In this 1913 postcard of Schenley Plaza, steps lead to the entrance of the Carnegie Library. On the left is a memorial to Pittsburgh mayor Christopher Magee, who played a large role in the development of the Oakland Civic Center. The memorial, which still stands, was created by sculptor Augustus Saint-Gaudens and unveiled in 1903. (PHLF.)

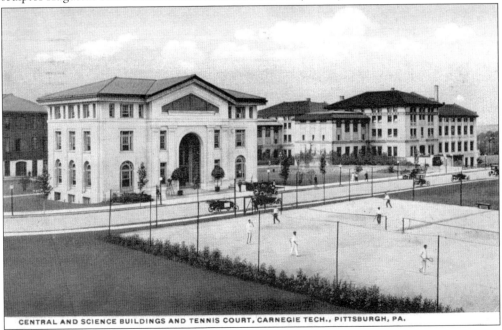

CENTRAL AND SCIENCE BUILDINGS AND TENNIS COURT, CARNEGIE TECH., PITTSBURGH, PA.

Carnegie also founded the Carnegie Institute of Technology, which opened in 1906. The school was intended to provide technical training for careers in industry. Architect Henry Hornbostel designed the campus in a deep U-shaped plan, with the open end of the U seen in this view from 1918. The Hunt Library was later built on the site of the tennis courts.

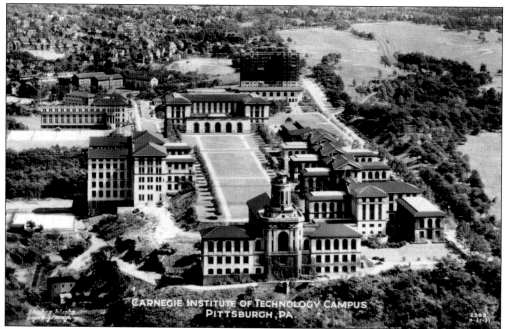

By the time of this 1931 postcard, the original campus of Carnegie Institute of Technology (now Carnegie Mellon University) was virtually complete. Machinery Hall (1913) stands at the base of the U–shaped plan. The College of Fine Arts (1915) stands across the open end of the U. Behind it rises the prestigious Park Mansions apartment building at the edge of Schenley Park. (CLP.)

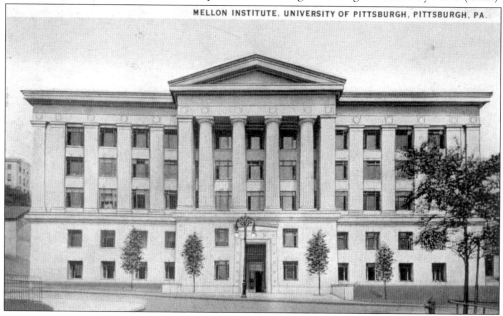

The Mellon family, owners and investors in many of the great industries of Pittsburgh, had a strong interest in scientific research that would benefit industry. Andrew and Richard B. Mellon founded the Mellon Institute for Industrial Research in 1913 to further this goal. Seen here in 1928, the first Mellon Institute building is now called Allen Hall and is part of the University of Pittsburgh. (PHLF.)

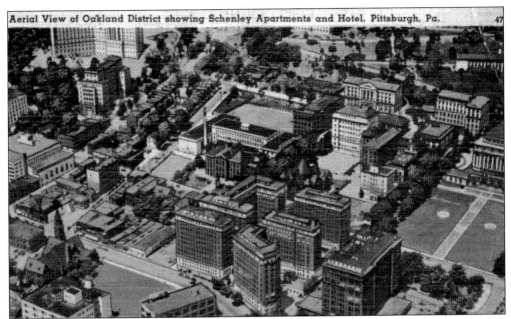

This aerial view of Oakland, taken about 1940, shows the hillside north and west of the Schenley Hotel, seen on the lower right. Behind the hotel rise the fashionable Schenley Apartments (1922), which are now dormitories for the University of Pittsburgh. At the top is the hillside campus of the university; on the upper left, the first buildings of the burgeoning medical center can be seen. (CLP.)

In the 1930s, the University of Pittsburgh established a medical center on the adjacent hillside by luring Presbyterian Hospital from the North Side. In this 1945 view, the components of the medical center are still separate and distinguishable, but after World War II, many new medical institutions and buildings swallowed up the adjoining residential neighborhood and created a seamless whole with the University of Pittsburgh campus.

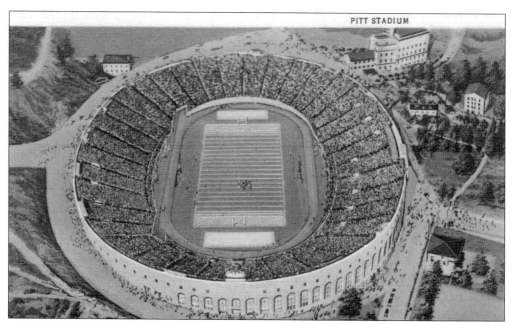

Initial plans for the University of Pittsburgh called for a campus that climbed the hillside north of Fifth Avenue but were abandoned in favor of the level quadrangle that exists today, anchored by the Cathedral of Learning. The hillside became the site of the university's 1925 football stadium, seen here during a game in 1941. The stadium was razed in 1999 for construction of a new basketball arena. (JDS.)

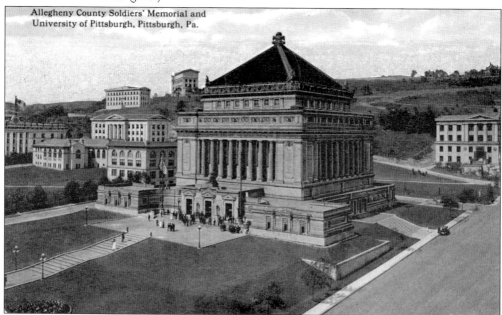

This 1915 postcard shows the Allegheny County Soldiers and Sailors Memorial, which opened in 1910, a long-delayed monument to Pittsburgh's Civil War heroes. Architect Henry Hornbostel's design was inspired by the ancient Mausoleum of Halicarnassus. Behind the memorial, the buildings of the University of Pittsburgh are scattered across the hillside, including the dental and medical schools near the top of the hill. (PHLF.)

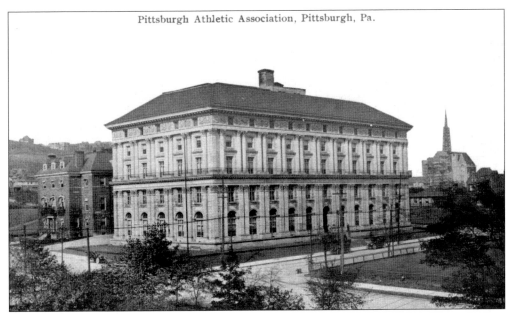

The Pittsburgh Athletic Association was newly established when its exquisite classical clubhouse, designed by Benno Janssen, was completed in 1911. Just behind is the original University Club (1905), now demolished. In this 1912 view, construction of the Masonic temple is still in the future. On the horizon is the First Baptist Church, designed by Bertram Goodhue, surrounded by scaffolding in the final stages of its construction. (CLP.)

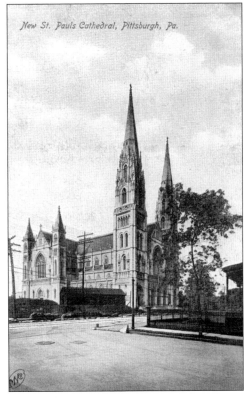

The Catholic Diocese of Pittsburgh joined the migration of institutions to Oakland with construction of St. Paul's Cathedral on Fifth Avenue, completed in 1906. The previous cathedral building of 1843 was downtown at Grant Street and Fifth Avenue (now the site of the Union Trust Building). The new cathedral was designed by Chicago architects Egan and Prindeville, who wrapped a wide five-aisle interior in a dignified Gothic Revival skin.

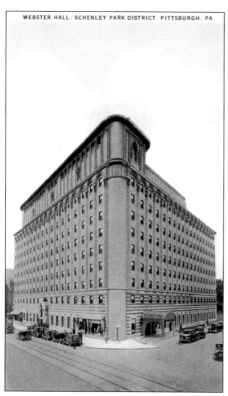

Webster Hall, designed in Italian Romanesque style by architect Henry Hornbostel, was the home of a large men's club and hotel when it was built in 1926. The club went out of business during the Great Depression, but the hotel remained in business for years. Eventually Webster Hall became an apartment building. Today it houses a mixture of condominiums and offices. (PHLF.)

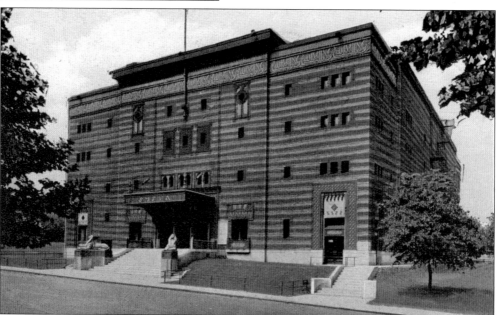

The Syria Mosque was constructed in 1915 as the headquarters of Pittsburgh's Shriners. Seen here in 1928, it was for many years an important venue in the cultural life of the city, serving as home to the Pittsburgh Symphony Orchestra and the site of numerous concerts and political rallies. The Shriners moved to the suburbs, and the building was razed in 1991 to be replaced by a parking lot.

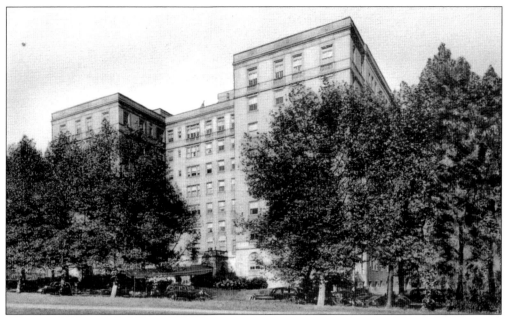

The Ruskin Apartments, seen here about 1930, were built in an elegant but simplified classical style in 1923. The Ruskin was one of the first of a new kind of building—the apartment hotel. Rental of these apartments included the amenities of a hotel, such as an in-house restaurant and maid service. The University of Pittsburgh purchased the Ruskin in 1958 and converted it into student apartments. (CLP.)

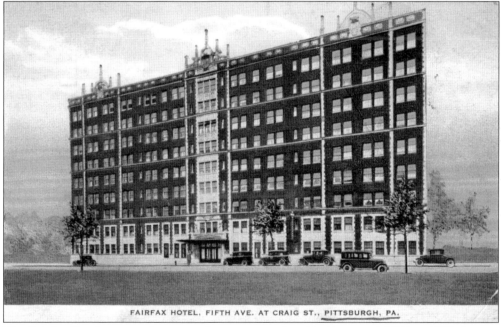

FAIRFAX HOTEL, FIFTH AVE. AT CRAIG ST., PITTSBURGH, PA.

The Fairfax Hotel was another upmarket apartment hotel built around 1925 on Fifth Avenue just east of St. Paul's Cathedral. It consists of nine stories of brick facade with a veneer of Tudor/Jacobean ornament, rising to three crowning compositions of circles, strapwork, and obelisks in stone at the skyline. The Fairfax serves to this day as an elegant apartment building. (CLP.)

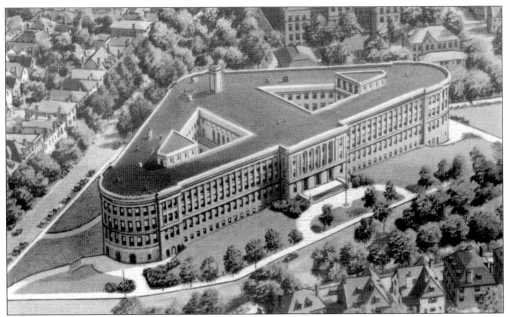

Schenley High School was the crown jewel of the Pittsburgh Board of Education for many years. It was designed and built in 1916 to fit a difficult site on a hill above the Schenley Farms neighborhood and was known as the country's first "million-dollar school." This aerial view from around 1940 reveals the school's triangular floor plan, arrangement around two interior light courts, and classical facade. (JDS.)

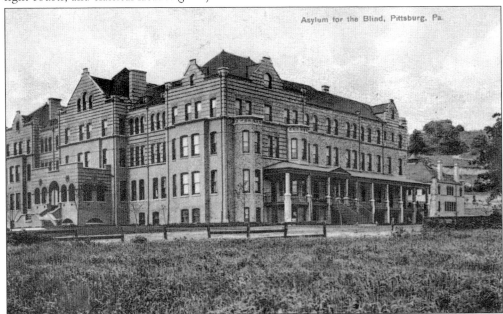

Mary Croghan Schenley donated land for the Asylum for the Blind (1894), one of the first institutions to be built in the Oakland Civic Center. The original building, shown here in 1910, was designed in a kind of striped Italian Romanesque manner, with hints of Ruskinian Gothic and classical revival mixed in. The school has expanded dramatically to the north in recent years. (PHLF.)

One of the goals of the developers of the Oakland Civic Center was to attract enough clubs to the area to make it the center of elite social life in Pittsburgh. The Concordia Club of 1913, designed in classical revival style, was and remains one of Pittsburgh's preeminent clubs. Other such institutions nearby included the Pittsburgh Athletic Association, the Twentieth Century Club, the University Club, and the Masonic temple.

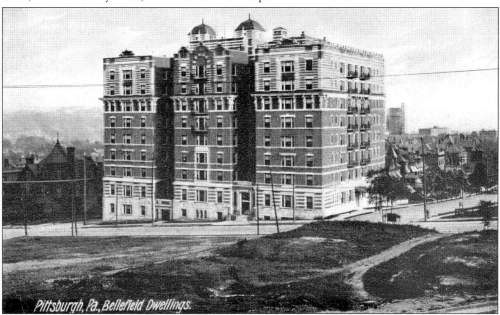

The first major apartment building in Pittsburgh was the Bellefield Dwellings, shown here about 1905 shortly after its construction at Centre Avenue and Dithridge Street. In an attempt to overcome the stigma of tenement buildings and attract wary middle-class renters, early apartment buildings were designed to look dignified and luxurious. Scaffolding around the new St. Paul's Cathedral can be seen just to the right of the building, on the horizon.

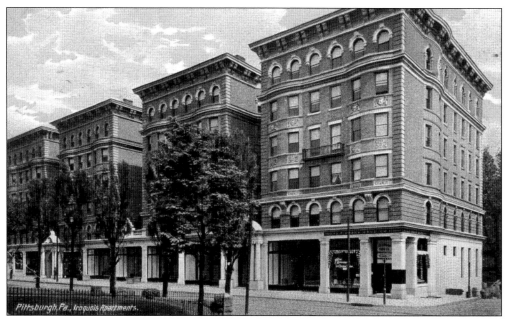

Another substantial early apartment building in Pittsburgh was the 1903 Iroquois Apartments. The rounded bays on the facades are reminiscent of houses in Boston's prestigious Back Bay. The Iroquois has been a fixture of the university shopping district for many years. In 1911, when this view was taken, the building dominated Forbes Avenue. Now in use as a medical office building, it is visually overwhelmed by subsequent development. (JDS.)

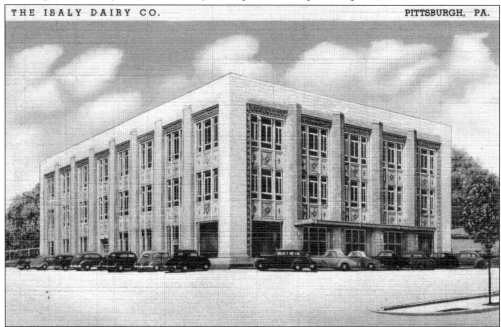

The Isaly Dairy Company's chain of food and ice-cream stores was a fixture in the life of Pittsburgh neighborhoods for much of the 20th century. Founded 1902 in Mansfield, Ohio, the firm expanded into Pittsburgh in the 1930s. Isaly's occupied this 1931 art deco ice-cream plant on Boulevard of the Allies in Oakland. The building is now used for medical offices.

Seven

EAST LIBERTY

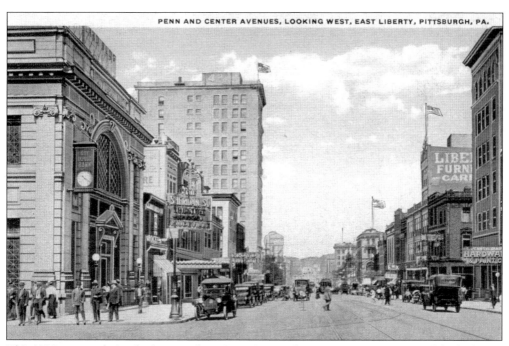

PENN AND CENTER AVENUES, LOOKING WEST, EAST LIBERTY, PITTSBURGH, PA.

This 1920s postcard view looks west along Penn Avenue from Centre Avenue toward the high-rise East End Savings and Trust Company building at Penn and Highland Avenues. The City Deposit Bank's classical domed building, near left, was replaced by the modernist Mellon Bank building in 1970. Nearby was the Sheridan Square Theater, demolished 1990, where young Gene Kelly worked as an usher. The six-story Romanesque Liberty Building on the right survives and was recently renovated.

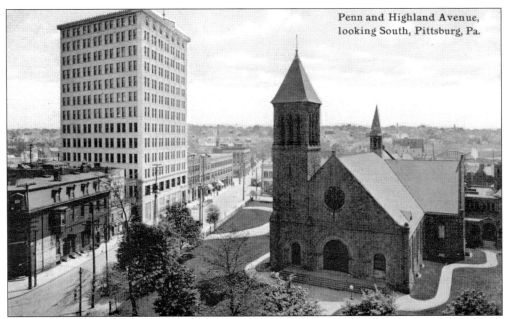

The fourth incarnation of East Liberty Presbyterian Church, a straightforward Romanesque design by Pittsburgh architects Alden and Harlow, was built in 1888 and razed in the 1930s. This 1912 postcard also features the classical-style Highland Building across the street, commissioned by Henry Clay Frick in 1910. The 1870s mansard-roofed building on the corner of Penn and Highland Avenues was the first home of the East End Savings and Trust Company.

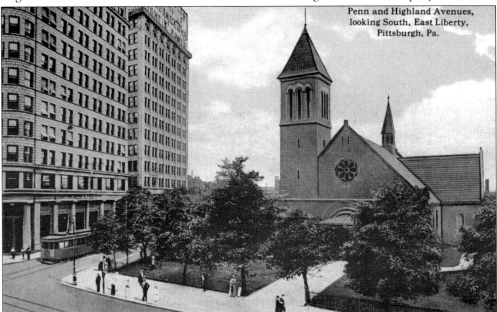

This postcard shows the intersection of Penn and Highland Avenues a few years later. The Victorian-era building that had occupied the southeast corner was replaced by a new high-rise office building for the East End Savings and Trust Company, constructed in 1913. The Highland Building in the meantime had sprouted an enormous rooftop electric sign for the County Light Company.

The growth of East Liberty in the early 20th century created a demand for office space. The East End Savings and Trust Company addressed that need with its new high-rise building, seen here in 1921. This handsome office tower and its neighbor, the Highland Building, brought an intensely urban character to East Liberty. It was demolished in 1970 and replaced with a one-story bank branch.

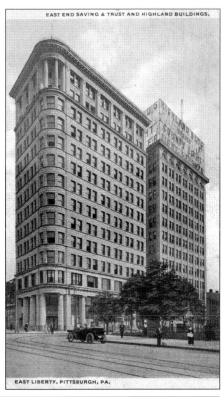

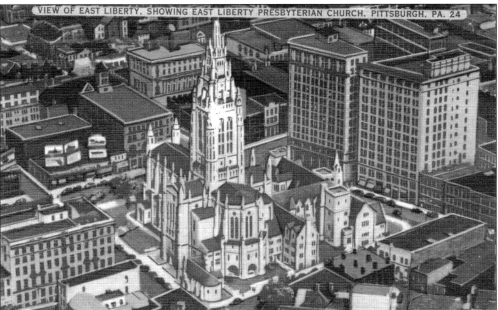

This aerial view from about 1940 of East Liberty Presbyterian Church reveals the massive scale of this building, constructed with Mellon family funds to the Gothic Revival design of Ralph Adams Cram and completed in 1935. In true medieval style, the donors are interred in a side chapel. The church physically dominates the East Liberty business district, which at the time of its construction was the third-largest commercial area in the state.

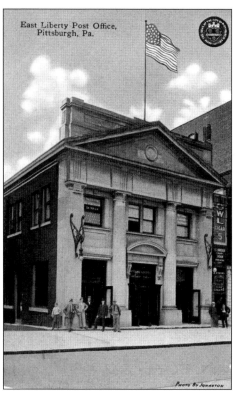

East Liberty Post Office,
Pittsburgh, Pa.

Photo by Johnston

Over the years, the post office occupied several different sites in East Liberty. This postcard view dates from between 1905 and 1915. It is unclear where exactly this building was located, but recent research findings indicate that it may have stood in the 100 block of South Highland Avenue, just south of and across the alley from the Highland Building.

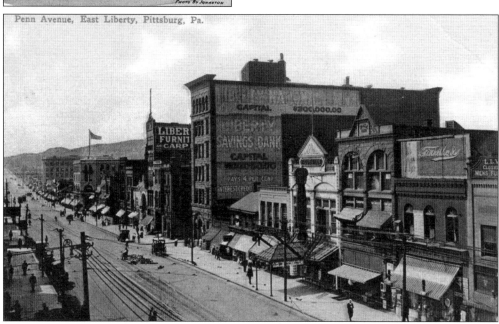

Penn Avenue, East Liberty, Pittsburg, Pa.

This 1912 postcard view looking west along Penn Avenue shows the street in the early years of its commercial glory. The C. H. Rowe Department Store stands under a flag in the middle distance at Highland Avenue. The Romanesque-style Liberty Building (1890), in the middle with all the painted signs, still stands today. The buildings to its right were remodeled out of recognition in the 1960s. (CLP.)

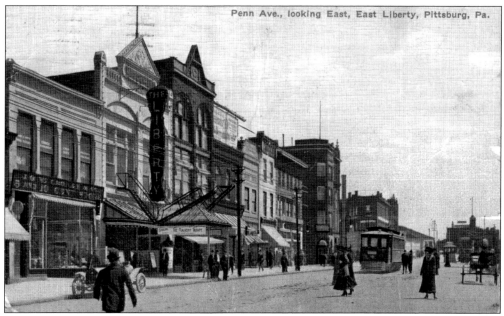

This 1911 view of Penn Avenue looks east from the intersection with Sheridan Avenue. It shows some of the same buildings as the previous postcard, including the McCrory's five-and-dime store on the left and the Liberty Theater with its odd fire escape extending out over its canopy. The business district extended for several blocks beyond this point but was truncated at the end of this block during urban renewal. (HHC.)

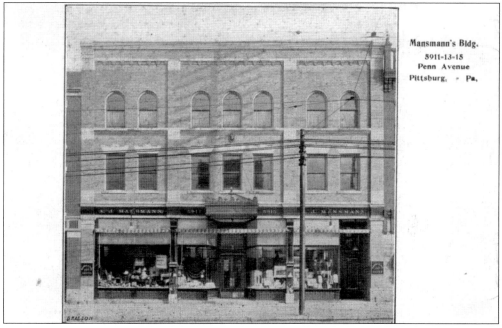

Mansmann's Bldg.
5911-13-15
Penn Avenue
Pittsburg, - Pa,

As East Liberty grew, a number of department stores opened to serve customers who preferred not to travel downtown. Prominent among these was Mansmann's Department Store on Penn Avenue, shown here in 1908. Mansmann's remained a vital part of East Liberty until it closed in the 1970s. The building still stands two blocks west of Highland Avenue. (JDS.)

89

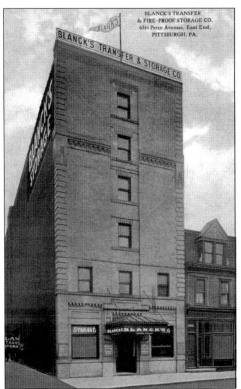

East Liberty was a country market village that developed into a small-scale neighborhood business district. As it grew dramatically at the dawn of the 20th century, the commercial district consumed surrounding residential streets and older business sections. The 1912 Blanck's Transfer building overtops its older Victorian storefront neighbor in this 1934 advertising postcard. The site is now occupied by the Village of Shadyside town house development. (JH.)

The East Liberty station of the Pennsylvania Railroad was constructed in 1906 to the design of Philadelphia architect Frank Furness. This postcard view from the 1920s shows the approach drive to the station from the east off Dahlem Street (now East Liberty Boulevard). The station was demolished in 1963, and the site is now occupied by the Village of Eastside shopping center. (HHC.)

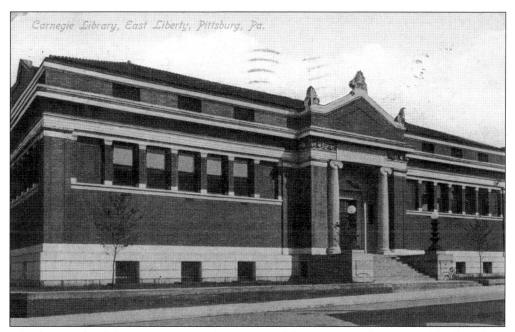

After he completed the construction and expansion of the Carnegie Library in Oakland, Andrew Carnegie endowed a number of neighborhood branch library buildings throughout the city, all designed by Alden and Harlow. The East Liberty Library (1903) on Larimer Avenue was the most formal and stately, owing to its location in Pittsburgh's "second downtown." This building was demolished and the library branch relocated during the 1960s urban renewal project. (JDS.)

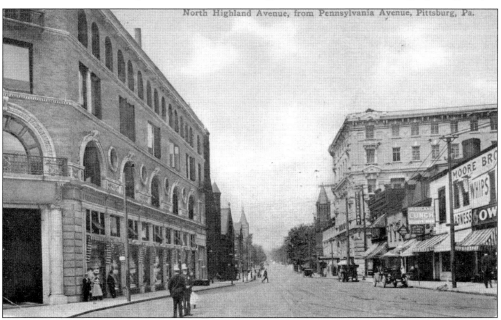

In this 1915 view of Highland Avenue north from Penn Avenue, the C. H. Rowe (later May and Stern) Department Store dominates the corner, while the five-story Rittenhouse Hotel rises across the street. Farther north stand the towers of the Emory Methodist Episcopal Church on the left and the Sixth United Presbyterian Church (now Eastminster Presbyterian) on the right.

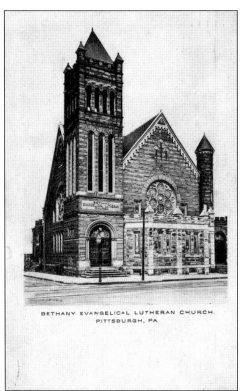

BETHANY EVANGELICAL LUTHERAN CHURCH.
PITTSBURGH, PA

The Bethany Evangelical Lutheran Church was erected in the 1890s just north of the C. H. Rowe Department Store building at the corner of Highland Avenue and Kirkwood Street. It was designed in the widely admired Richardsonian Romanesque style, right down to the miniature version of the Allegheny County Courthouse tower. The church was razed during the 1960s urban renewal project and was replaced by an office building. (HHC.)

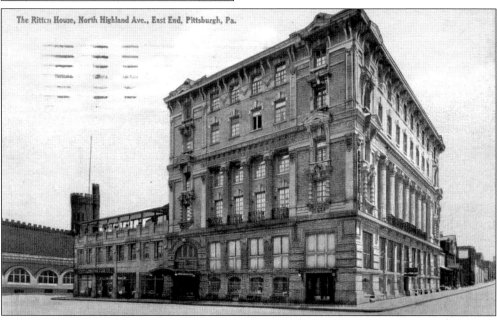

The Rittenhouse Hotel was built in 1912 at Highland Avenue and Kirkwood Street. The center of elegant East Liberty social life for many years, it was an exuberant Beaux-Arts building designed by architect Carlton Strong. There appears to be a roof garden above the adjacent storefront. Engine Company No. 8 is just to the north across Broad Street. The Rittenhouse Hotel was demolished in the mid-1960s during urban renewal.

Police stations and firehouses were tangible symbols of city government, and the city made them domestic or formal in character, depending on the neighborhood setting. Engine Company No. 8, a mixture of Gothic, Romanesque, and fantasy castle styles, was built in 1896 at the corner of Highland Avenue and Broad Street. It too was a victim of the 1960s urban renewal project.

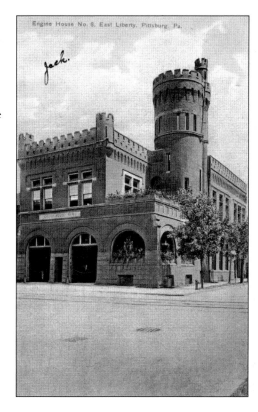

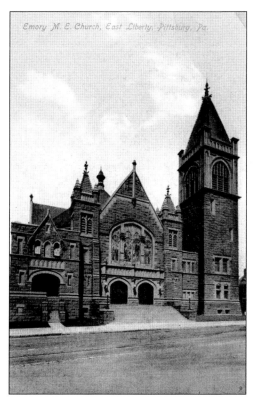

As the residential population grew in the early 20th century, churches sprang up throughout the East End. The Emory Methodist Episcopal Church erected this Gothic Revival building on Highland Avenue, shown in this 1909 postcard, in a residential section several blocks north of Penn Avenue. This building burned in 1971 and was replaced by the modern brick church that now stands across from the Home Depot store. (CLP.)

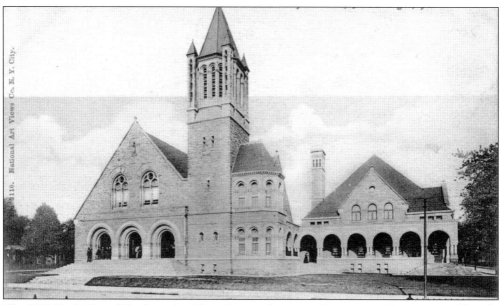

The 1893 Sixth United Presbyterian Church is now known as Eastminster Presbyterian Church. It was designed by William S. Fraser in the fashionable Richardsonian Romanesque style. Seen here in 1910, the church occupied a gracious setting along tree-lined Highland Avenue in the affluent suburb north of the East Liberty commercial core. The church's environs changed dramatically as the expanding East Liberty shopping district engulfed surrounding blocks during the 1920s.

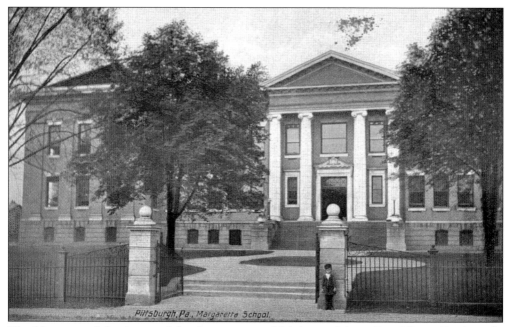

The Margaretta School, named for the street on which it stood (now East Liberty Boulevard), was built in the 1890s as an elementary school. In the early 20th century, it was remodeled as Peabody High School, named after a prominent local physician. Peabody is the alma mater of East Liberty native Gene Kelly and many other prominent Pittsburghers.

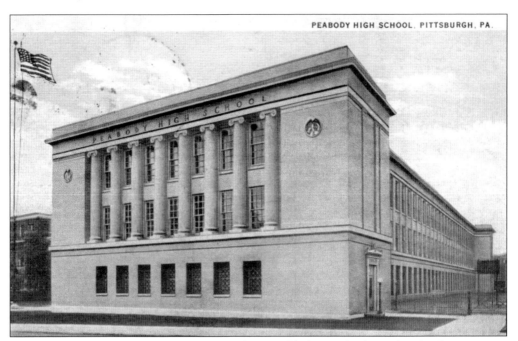

In the 1920s, a new wing in the classical style was added to Peabody High School, containing classrooms, an auditorium, and a gymnasium. In the 1970s, both sections of the school were wrapped in a featureless and almost windowless redbrick cladding. The only elements that survived were the four columns of the original Margaretta School portico. (PHLF.)

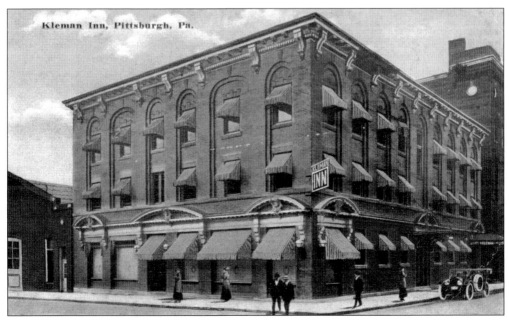

Kleman Inn, Pittsburgh, Pa.

East Liberty at the beginning of the 20th century boasted several hotels, owing in part to the presence of the East Liberty railroad station. The Kleman Inn was not as large or elaborate as the Rittenhouse Hotel, but in this 1915 view, it stood proudly at the corner of Collins and Broad Streets a couple of blocks to the west of the station. (JH.)

East Liberty Academy, Pittsburg, Pa.

The East Liberty Academy was founded in 1890 in a large house at the corner of Linden Avenue and Meade Street on the fringe of East Liberty. It was one of Pittsburgh's most important college preparatory schools before World War I, specializing in a classical education. The school went out of business by the early 1920s, and by 1924, apartment buildings occupied the site. This postcard dates from 1919. (HHC.)

Pittsburg Hospital, Frankstown Ave. and Beachwood Boulevard, Pittsburg, Pa.

The Pittsburgh Hospital, founded by the Sisters of Charity in 1896, was originally located in a donated house on Stanton Avenue. Its first purpose-built structure was the five-story building shown in this 1909 postcard, constructed in 1905 at the corner of Fifth Avenue (now Washington Boulevard) and Frankstown Road. The building has a large 1950s addition and is now used by the Forbes Road Nursing and Rehab Center. (CLP.)

Eight

EAST END

NEIGHBORHOODS

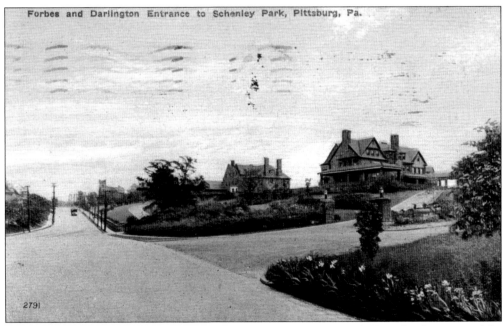

Forbes and Darlington Entrance to Schenley Park, Pittsburg, Pa.

2791

During the 1890s, the introduction of electric streetcars made the hills and valleys east of the Golden Triangle more easily accessible, and development rapidly followed. The East End held a promise of space and greenery away from the old crowded neighborhoods and smoky river valleys—exemplified by this 1911 postcard view of the Squirrel Hill entrance to Schenley Park. The mansion on the right belonged to William Larimer Mellon. (CLP.)

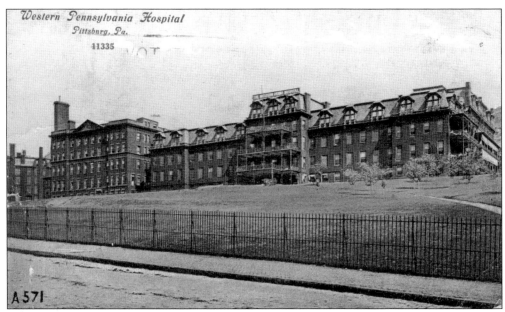

The Western Pennsylvania Hospital was founded in 1848 as the first public, nondenominational hospital in Pittsburgh. Its first building, where many wounded soldiers were treated during the Civil War, was erected in 1853 on the hillside overlooking the Strip District railroad yards at Twenty-eighth Street. This postcard view from about 1905 shows the original hospital building on the left end of the complex, with Victorian mansard-roofed additions to the right.

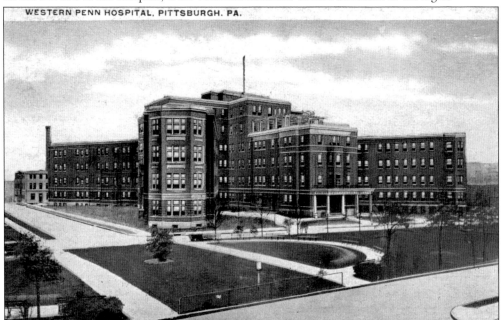

West Penn Hospital's original hillside location was abandoned due to difficulty of access and smoke from industries downhill. An entirely new hospital building was erected in the Bloomfield neighborhood in 1912. Shown in this 1921 postcard with Friendship Park in the foreground, the new hospital featured four-story wings radiating from a central core. This building still stands as the centerpiece of a complex of medical buildings.

Allegheny Cemetery was founded in 1844 as the fifth "rural park" cemetery in the United States. The original entrance was on Butler Street, the principal passage out of Pittsburgh along the Allegheny River valley. By 1887, a second entrance at the top of the hill on Penn Avenue was deemed necessary. The new entrance was designed in the Richardsonian Romanesque style made fashionable by the Allegheny County Courthouse.

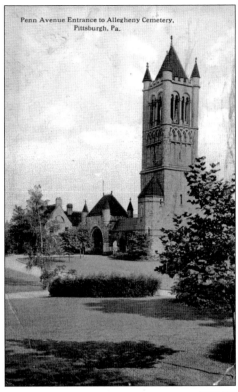

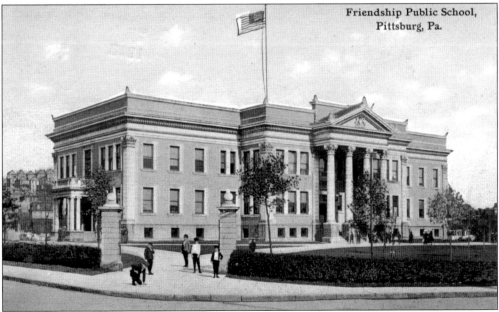

The Friendship neighborhood developed almost overnight. In 1890, the area was almost entirely vacant, and by 1910, it was almost completely developed. The 1899 Friendship School, designed by local architect Charles Bartberger, was erected in the midst of the neighborhood's comfortable Colonial and Tudor Revival houses. The building is a Beaux-Arts classical palace of education that is still in use. This postcard dates from 1912. (PHLF.)

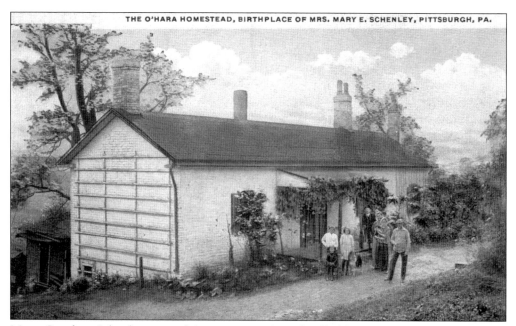

Mary Croghan Schenley, one of the greatest private landholders and public benefactors in Pittsburgh's history, was born in 1826 near Lexington, Kentucky. She was the granddaughter of Gen. James O'Hara, a pioneer soldier and Pittsburgh businessman who amassed most of the land that she eventually inherited. The location of the O'Hara Homestead shown in this postcard is unknown and poses a mystery for historians. (CLP.)

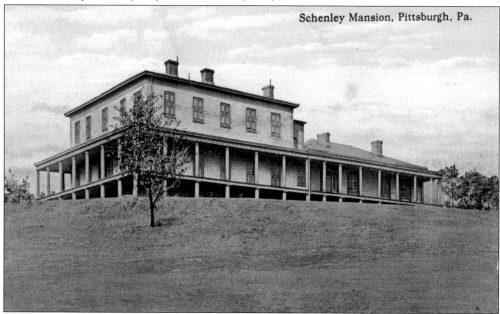

Schenley Mansion, Pittsburgh, Pa.

In 1842, Mary Croghan eloped to England with Edward Schenley. Her father tried to lure her back (unsuccessfully) by adding a ballroom to the 1835 family home, called Picnic House, in Stanton Heights. After sitting empty for nearly 100 years, the house, seen here in 1918, was demolished in the late 1940s. The ballroom was saved and reinstalled in the University of Pittsburgh's Cathedral of Learning. (PHLF.)

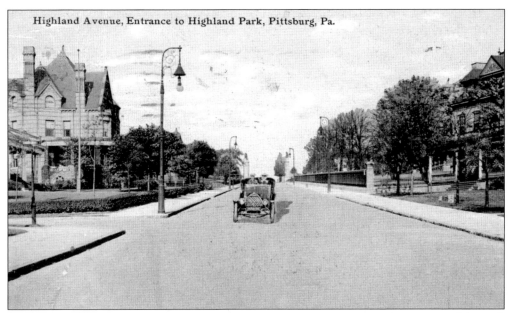

Highland Avenue, Entrance to Highland Park, Pittsburg, Pa.

The Highland Park neighborhood developed north of East Liberty at the beginning of the 20th century on land owned in part by members of the Negley family. Highland and Negley Avenues, the principal streets, were lined with the mansions of wealthy and prominent Pittsburghers. In this 1913 view of Highland Avenue, the entrance to the city park of the same name is just visible at the top of the hill.

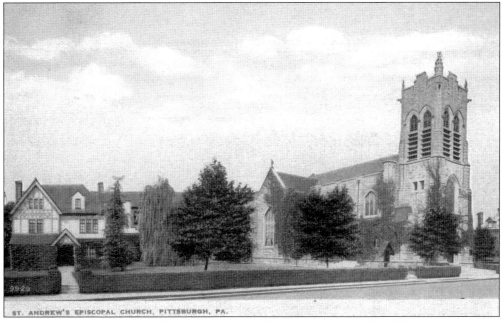

ST. ANDREW'S EPISCOPAL CHURCH, PITTSBURGH, PA.

St. Andrew's was the second Episcopal parish in Pittsburgh, founded in 1837. At the dawn of the 20th century, St. Andrew's joined the migration of churches out of downtown, following its parishioners as they moved out to the East End suburbs. Built in 1905 in English Romanesque style, St. Andrew's remains a vital part of the Highland Park neighborhood. This postcard dates from about 1920.

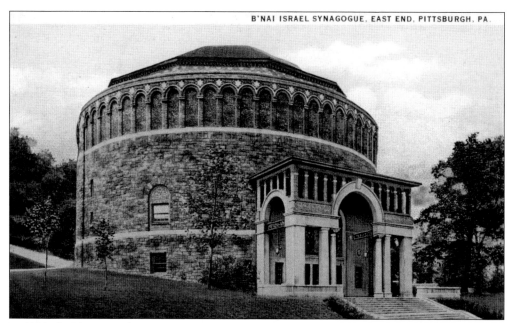

In 1923, the B'Nai Israel congregation commissioned architect Henry Hornbostel to design a new synagogue for a site on Negley Avenue at Rippey Street. Hornbostel designed a great circular stone drum with a domed roof and a classical entryway. B'Nai Israel flourished here, building a school addition in the 1950s, but it relocated out of the city in 1996. The school building is now used by an urban charter school. (HHC.)

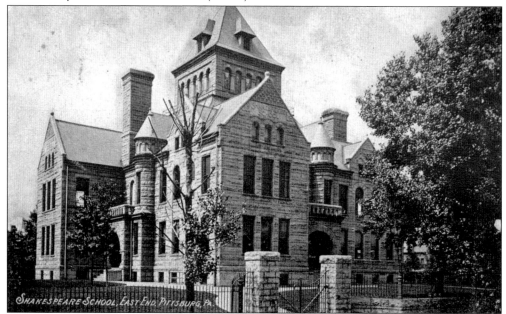

The Shakespeare School, seen here in 1910, was a landmark in Shadyside, standing near the corner of Penn and Shady Avenues. It was built in the 1890s in the fashionable Richardsonian Romanesque style. The building was demolished during the urban renewal project of the 1960s; the site, originally intended for one of the city's projected "great high schools," is now the location of a strip shopping center. (PHLF.)

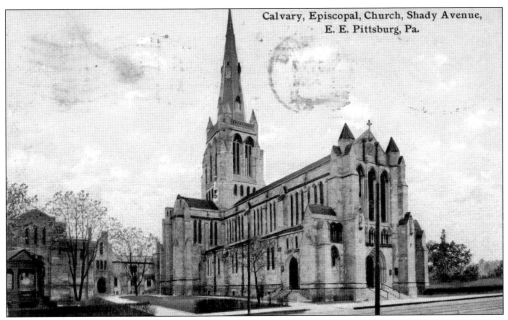

Calvary, Episcopal, Church, Shady Avenue,
E. E. Pittsburg, Pa.

Calvary Episcopal Church, completed in 1907, was the first Pittsburgh commission for Ralph Adams Cram, master architect of the Gothic Revival. The exterior design is fairly severe in its lack of ornament, but the massing of tower and spire at the crossing are magnificent. The construction of this building in the eastern section of Shadyside marked the ascendancy of Calvary as a principal Episcopal parish in the East End.

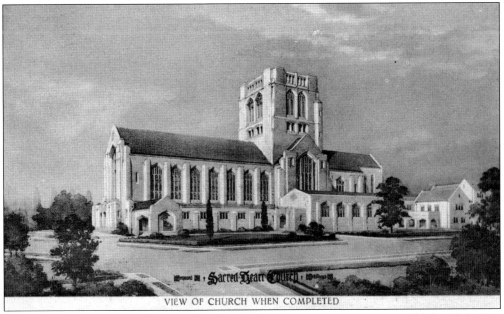

VIEW OF CHURCH WHEN COMPLETED

In 1924, the Roman Catholic parish of Sacred Heart moved from its 50-year-old church in East Liberty to a new building at Shady Avenue and Walnut Street across the street from Calvary Episcopal Church. The stone Gothic Revival structure was designed by Carlton Strong, a local specialist in church architecture. This postcard from the late 1930s shows the church as it would look when the tower was completed in 1953.

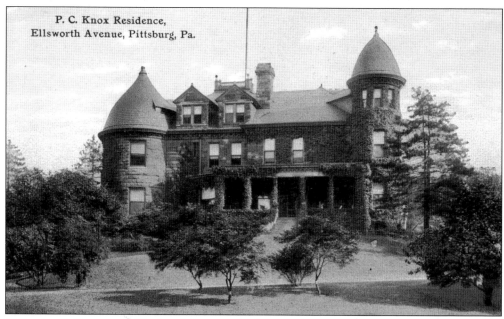

P. C. Knox Residence,
Ellsworth Avenue, Pittsburg, Pa.

Philander C. Knox was a Pittsburgh lawyer who became famous as counsel to the Carnegie Steel Company. He later served as U.S. attorney general (1901–1904), U.S. senator from Pennsylvania (1904–1909 and 1917–1921), and secretary of state under Pres. William H. Taft (1909–1913). His mansion, seen here about 1910, stood on Ellsworth Avenue east of the First Unitarian Church. The site is now occupied by a cul-de-sac of post–World War II houses. (JDS.)

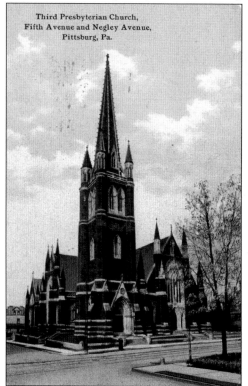

Third Presbyterian Church,
Fifth Avenue and Negley Avenue,
Pittsburg, Pa.

Third Presbyterian Church was one of three Presbyterian churches designed in Pittsburgh by Philadelphia architect Theophilus Chandler; another was the downtown First Presbyterian Church. Third Presbyterian was built in 1903 at the corner of Fifth and Negley Avenues in Shadyside. Spiky but sumptuous in its Gothic Revival design, the church stands today as a landmark at a prominent intersection. This postcard dates from 1911.

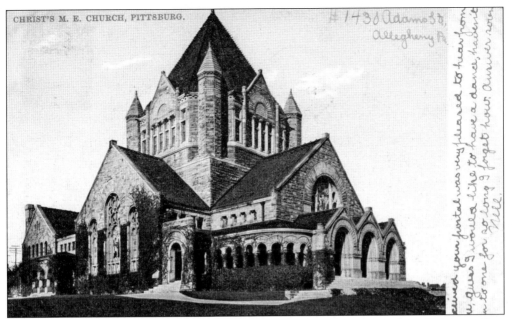

CHRIST'S M. E. CHURCH, PITTSBURG.

When downtown Christ Methodist Church burned in 1891, the congregation split in two. One group moved to the North Side and built Calvary Methodist Church. The other built Christ Methodist Church (1893), now known as First United Methodist, at Centre and Aiken Avenues. This is a fine example of a Richardsonian Romanesque lantern church, where the principal worship space is centered under the pyramidal tower roof.

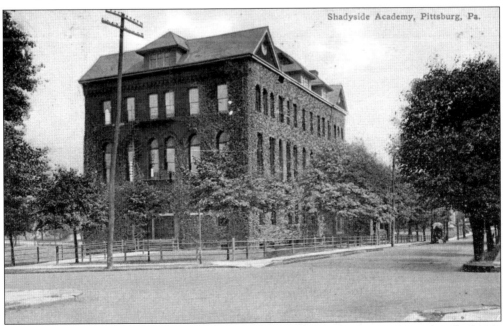

Shadyside Academy, Pittsburg, Pa.

The Shadyside Academy is a college preparatory school founded in 1883 in the Shadyside neighborhood. The school occupied this building, seen here in 1911, at the corner of Morewood and Ellsworth Avenues until relocating to suburban Fox Chapel in the 1920s. The site of this building is now the home of the Winchester Thurston School. (HHC.)

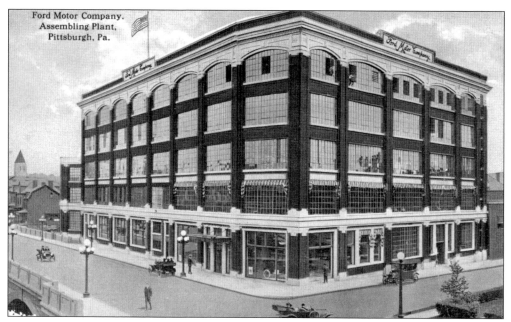

In 1915, the date of this postcard, the Ford Motor Company opened a combination assembly plant and showroom at Baum Boulevard and Morewood Street. Baum Boulevard is still known as "automobile row" for the many automobile-related businesses along most of its length. Until the 1930s, Ford built up to 100 Model T cars per day in this building, which now houses Papermart and other commercial enterprises. (JDS.)

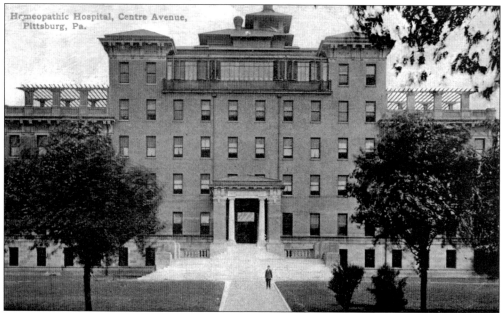

The Homeopathic Hospital was founded in downtown Pittsburgh in 1866 as a center for doctors practicing homeopathic medicine. In 1905, a decision was made to move to a new site on Centre Avenue in Shadyside, and the new hospital building opened in 1910. This building has lost its picturesque rooftop pergolas and has been subsumed in the massive University of Pittsburgh Medical Center Shadyside Hospital complex. (CLP.)

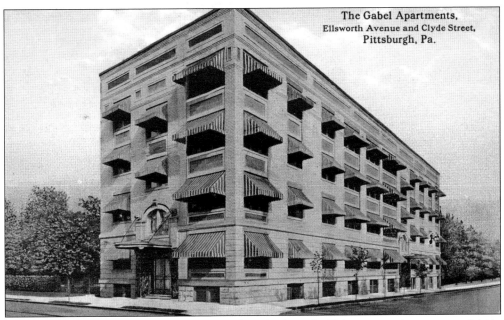

As East End neighborhoods attracted new residents in the early 20th century, the pressure of rising land values encouraged property owners to build more densely. Large apartment buildings and medium-sized ones, such as the Gabel Apartments in Shadyside, seen in this 1915 postcard, began to spring up throughout Oakland, Bellefield, and other popular locations. The Gabel's Ellsworth Avenue entrance was updated with Carrara glass probably during the 1930s. (HHC.)

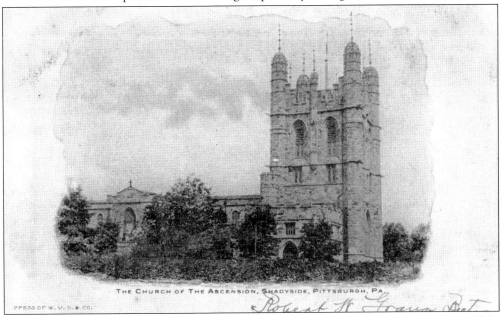

THE CHURCH OF THE ASCENSION, SHADYSIDE, PITTSBURGH, PA.

PRESS OF W. V. D. & CO.

The Church of the Ascension stands at the foot of Ellsworth Avenue at the intersection of the Shadyside and Oakland neighborhoods. It was erected in 1896 in a mixed Romanesque and Gothic style by William Halsey Wood, who won a national competition with this design. Seen here in a private mailing card from 1899, signed by the rector, is the landmark massive stone tower of the church. (HHC.)

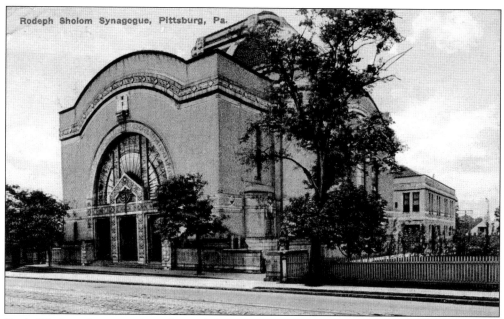

Rodeph Sholom Synagogue, Pittsburg, Pa.

Rodef Shalom Congregation relocated from downtown to Shadyside in 1907. It held a design competition for a new synagogue, which was won by Henry Hornbostel, architect of many prominent Pittsburgh buildings. His design included a massive Guastavino tile dome and decorative terra-cotta on a yellow brick exterior. Rodef Shalom remains a vibrant center of Reform Judaism in Pittsburgh to this day. (HHC.)

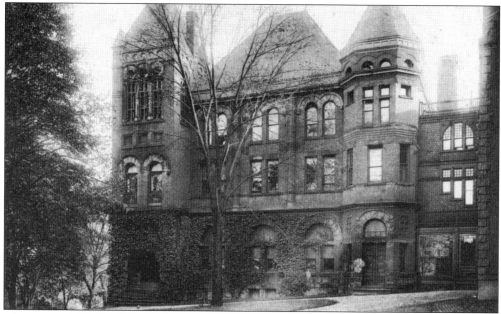

The Pennsylvania College for Women, now Chatham University, was established in 1869 in a mansion on secluded Woodland Road on Squirrel Hill. Joseph Dilworth, one of the founders, donated funds for the construction of an addition to the original building in 1888. Dilworth Hall contained classrooms, dormitories, and a chapel with a large Tiffany window; it is no longer extant. This postcard dates from about 1910.

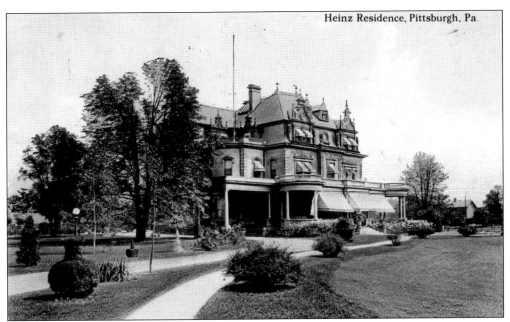

Henry J. Heinz was a farmer in suburban Sharpsburg before he made his fortune in food processing and bottling. In 1892, he purchased an 1870s Italianate house on millionaires' row on Penn Avenue in Point Breeze. Architect Frederick Osterling was commissioned to transform the house into a chateauesque mansion, seen here about 1912. The mansion was demolished in 1922 to make way for a housing development.

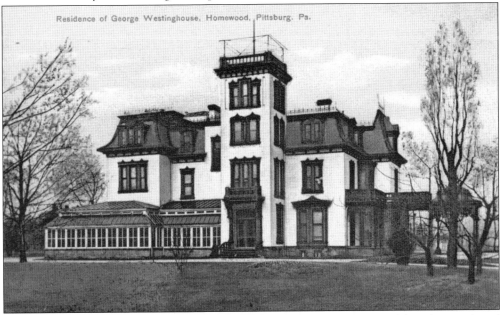

Residence of George Westinghouse, Homewood, Pittsburg. Pa.

In 1871, George Westinghouse, inventor of the air brake and an entrepreneurial genius, purchased a fashionable Second Empire–style house on Thomas Boulevard in the Homewood section of Pittsburgh and named it Solitude. He lived there until his death in 1914. The house, shown here around 1910, was razed in 1918. Comprising a full city block, the estate was donated to the city as Westinghouse Park.

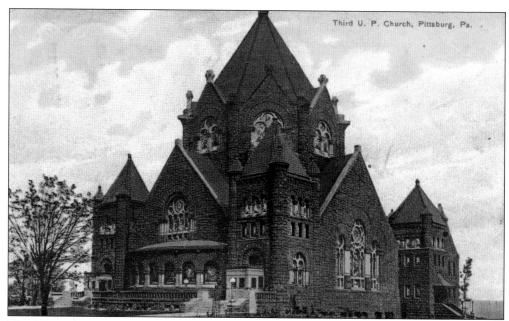

The 1890s Third United Presbyterian Church, built in the Richardsonian Romanesque style, was another example of the lantern-style church popular among Presbyterians in Pittsburgh. It stood at the corner of Shady Avenue and Northumberland Street in the Squirrel Hill neighborhood. The church was demolished in 1967, and the Rehabilitation Institute was built on the site. This postcard view dates from 1912. (PHLF.)

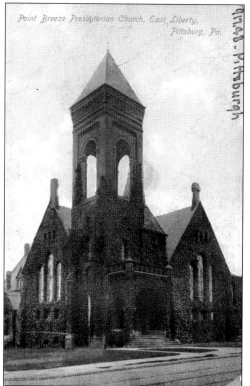

The Point Breeze neighborhood in Pittsburgh was named after a tavern that stood at the intersection of Penn and Fifth Avenues. In 1887, the Point Breeze Presbyterian Church, seen covered with ivy about 1910, was erected at that intersection and became a local architectural landmark. Its tall tower and ornamented porch stand out today as home of St. Paul's Baptist Church. (CLP.)

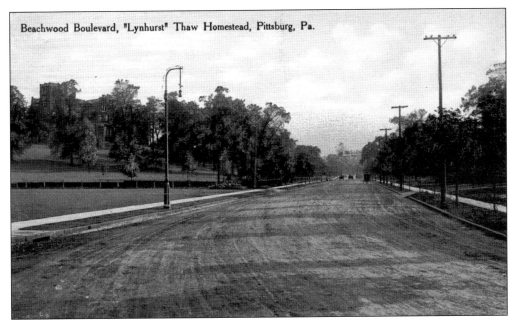

Beechwood Boulevard, "Lynhurst" Thaw Homestead, Pittsburg, Pa.

Beechwood Boulevard was designed by public works director Edward Bigelow as a wide, curvilinear avenue connecting Schenley and Highland Parks through the Squirrel Hill neighborhood. Some of Pittsburgh's wealthiest families built mansions on the boulevard, including the Thaw family, whose home, Lyndhurst, seen in the left background of this 1910 postcard, was erected in the 1890s. A residential cul-de-sac now occupies the site. (JH.)

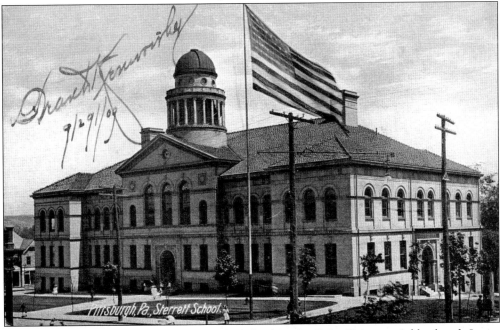

The Sterrett School was the primary public school in the Point Breeze neighborhood. It was a first-class facility attended by scions of the wealthiest families. Built at the dawn of the 20th century in the fashionable classical revival style, the school was noted for its luxurious finishes and special features such as an observatory, which can be seen in this postcard view of 1912.

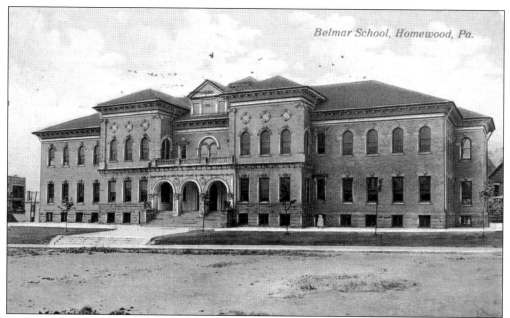

As the East End grew, remote neighborhoods like Homewood, previously populated by suburban villas and millionaires' mansions, began to attract residents of more modest means. With them came stores, churches, and schools, including the Belmar School, shown here around 1900 shortly after its construction in a Renaissance-inspired classical revival style. The school is still in use today. (PHLF.)

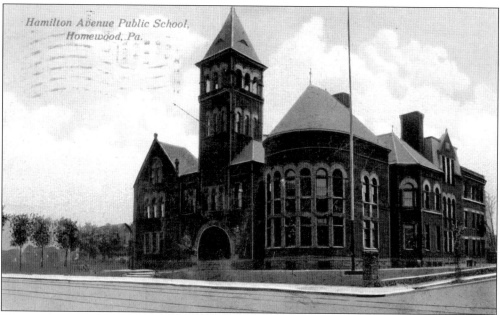

The Hamilton Avenue (later Homewood) Public School, shown here in 1912, was the principal public school in the Homewood neighborhood. It was designed in the Richardsonian Romanesque style, including a bell tower that resembled the tower of the Allegheny County Courthouse. This handsome building, now demolished, stood across the street from the Homewood branch of the Carnegie Library. (HHC.)

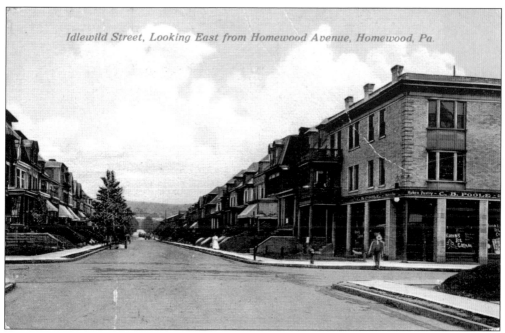

Idlewild Street, Looking East from Homewood Avenue, Homewood, Pa.

This block of Idlewild Street just east of Homewood Avenue was fairly typical of the Homewood neighborhood when this 1914 view was taken. These row house dwellings were built for families of modest means. Long blocks of row houses can still be seen on many neighboring streets. (HHC.)

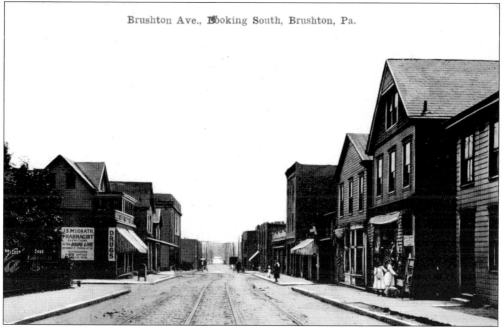

Brushton Ave., Looking South, Brushton, Pa.

Brushton was the name of the neighborhood north of Homewood, extending from the flat area along Frankstown Road into the hills of the Lincoln-Lemington neighborhood. It had a rougher, less affluent character than Homewood, as the frame houses and shops in this postcard from 1910 indicate. (HHC.)

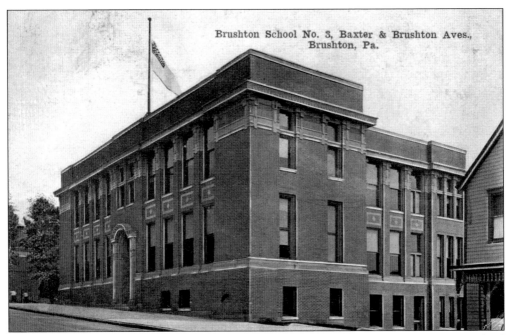

The Brushton School was erected in 1908, designed by progressive Pittsburgh architects Kiehnel and Elliott, whose experimentation with contemporary ornament can be seen in this 1914 postcard. A large addition was made to the school in 1929, and for a time it became Baxter High School. The building is still in use as a public school. (HHC.)

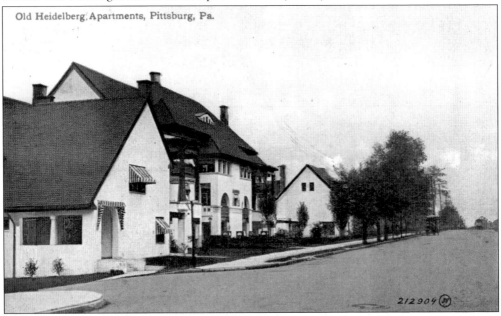

Old Heidelberg Apartments, Pittsburg, Pa.

The Old Heidelberg Apartments on Braddock Road in the Park Place neighborhood were designed by local architect Frederick Scheibler in 1905. Scheibler was influenced by the contemporary work of the Viennese Secession movement in Europe, as seen in the simple massing under a large roof, stucco surfaces, and artistic ornamentation. Seen here in 1910, the Old Heidelberg remains a desirable address today. (JH.)

Nine

PASTIMES

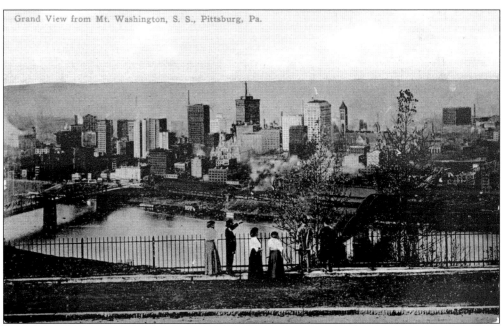

Grand View from Mt. Washington, S. S., Pittsburg, Pa.

Even though Pittsburgh was known as a town where work came first, people could still find time for sightseeing. The panoramic view of downtown Pittsburgh from Mount Washington was as spectacular then as it is now—at least when the smoke cleared, as it did on this sunny day in 1910. (HHC.)

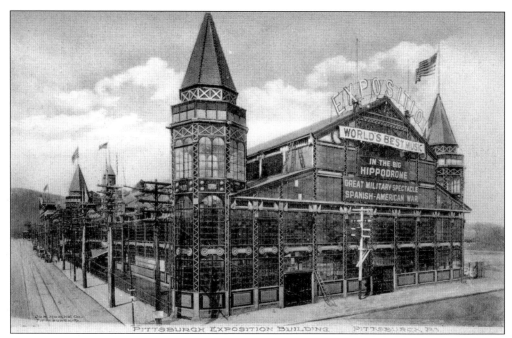

The Exposition Building at the Point in downtown Pittsburgh was a kind of Crystal Palace, with walls and towers of glass in a light steel framework. It was home to the "World's Best Music," and from time to time staged re-creations of historic events, such as the "great military spectacle" of the Spanish-American War advertised in this 1905 postcard. (HHC.)

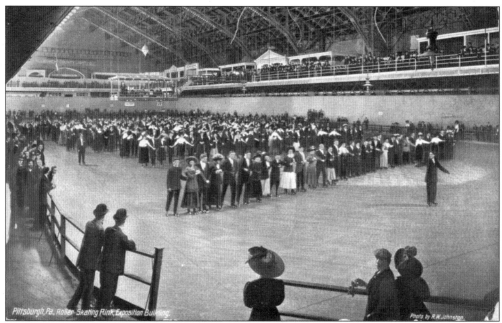

With the floor cleared of booths and goods, the Exposition Building could be the site of sporting events, historical spectacles, or roller-skating, when that fad swept the country in the early 1900s. In this scene from 1909, well-dressed Pittsburghers stand in formation on their skates, awaiting directions from their instructor.

PRINCIPAL SCENE IN THE GREAT NAVAL BATTLE SPECTACLE "THE BATTLE OF THE MONITOR AND MERRIMAC." A THRILLING REPRODUCTION OF THE FIGHT BETWEEN THE FIRST IRONCLADS EVER BUILT. NOW EXHIBITED AT THE PITTSBURG EXPOSITION, PITTSBURG, PA., SEPT. 1ST TO OCT. 23.

This souvenir postcard advertised a thrilling re-creation of the Civil War battle between the ironclad ships *Monitor* and *Merrimac*, on display at the Exposition Building. The spectacle was developed for the 1907 Jamestown Exposition in Virginia and was such a hit that it went on tour for the next few years. On the back of the card is written, "Willard got this card at the Exposition, September 13 1909." (CLP.)

Brunot's Island Race Track, showing Glen H. Curtis in his "Sky Lark," Pittsburg, Pa.

This postcard commemorates the first air show held in Pittsburgh. Less than six years after the Wright brothers' first flight, the Aero Club of Pittsburgh was founded to bring aviation pioneer Glenn Curtiss and his Air Meet to town. The Aero Club leased the racetrack on Brunot's Island in the Ohio River, and in August 1909, Curtiss demonstrated the feasibility of heavier-than-air flight to a large crowd of Pittsburghers.

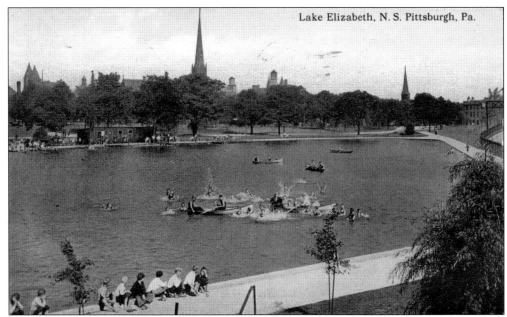

Lake Elizabeth, N. S. Pittsburgh, Pa.

Lake Elizabeth was the principal water feature of the Allegheny Common Parks when they were completed in 1876. Although immediately adjacent to a railroad line, it was a popular location for boating and swimming. The tall, narrow steeple of St. Peter's Church dominates the skyline in this 1912 view. Lake Elizabeth was later filled in and then restored in a modern form during a 1960s remodeling of the park. (JH.)

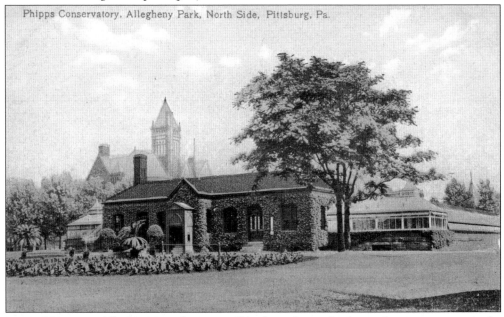

Phipps Conservatory, Allegheny Park, North Side, Pittsburg, Pa.

Henry Phipps, an Alleghenian and partner of Andrew Carnegie, donated a conservatory to the city of Allegheny in 1888, three years before he offered one to Pittsburgh. This 1910 postcard shows the conservatory, which stood in West Park, with the Allegheny High School in the background. The building was abandoned after sustaining damage in the great gas explosion of November 1927. The National Aviary now stands in its place. (JDS.)

118

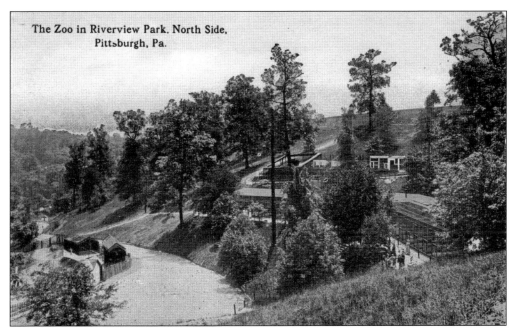

The Zoo in Riverview Park. North Side.
Pittsburgh, Pa.

Riverview Park on the North Side was the city of Allegheny's answer to Pittsburgh's landscape park system. A large park with steep hillsides, Riverview Park became the site of the Allegheny Observatory and was adorned with attractions such as this small zoo, seen here in 1905. After the merger of the two cities, this zoo was shuttered and the animals transferred to the zoo in Highland Park. (JH.)

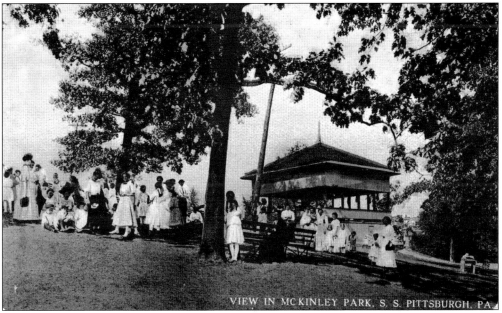

VIEW IN MCKINLEY PARK, S. S. PITTSBURGH, PA.

While the City of Pittsburgh was developing large regional parks in the East End and the North Side, it was also providing smaller neighborhood parks for communities on the South Side. This 1910 postcard shows a gathering around a shelter or bandstand in McKinley Park, which sits just south of the Beltzhoover neighborhood on the back side of Mount Washington. (HHC.)

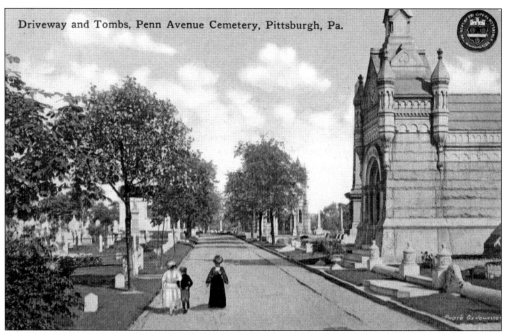

Driveway and Tombs, Penn Avenue Cemetery, Pittsburgh, Pa.

Rural-style cemeteries such as the Allegheny Cemetery in Pittsburgh developed in a time before public parks existed and were popular because they provided much-needed green space for walking and recreation. In this 1910 postcard, pedestrians in the cemetery enjoy the architectural wonders of this "city of the dead." (HHC.)

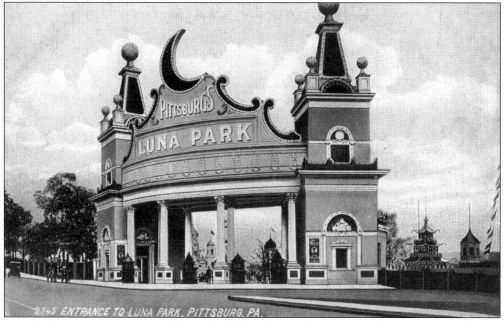

2745 ENTRANCE TO LUNA PARK. PITTSBURG. PA.

Luna Park was an amusement park built in 1905 at Baum Boulevard and Craig Street in the area north of Oakland. It was sponsored by a traction company to attract riders to its trolley line and was named after the famous Luna Park at Coney Island. The entrance, shown here, was classically sober below and an architectural fantasy above. Luna Park closed after only four seasons.

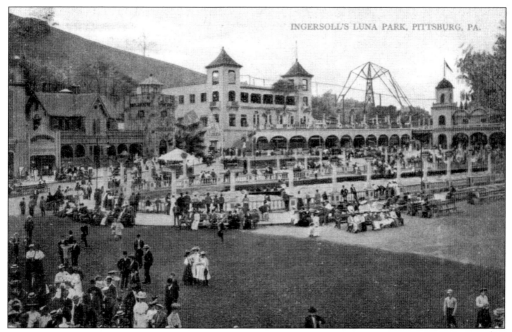

Luna Park was relatively sedate as amusement parks go, with a shoot-the-chutes and swing rides among the restaurants, stage shows, and other attractions. One of its claims to fame was that it was completely illuminated by electricity. Luna Park's decline began when a tiger on display got loose and mauled a female visitor to death. (JDS.)

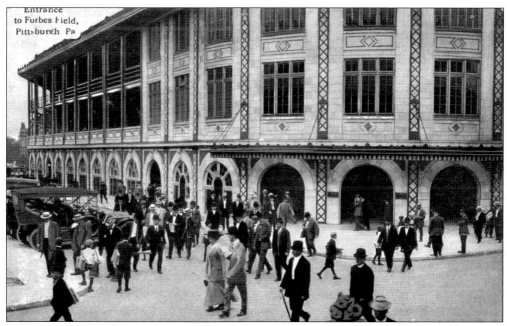

In 1909, the Pittsburgh Pirates built Forbes Field in Oakland to replace the flood-prone Exposition Park on the North Side, joining the migration of clubs and institutions to the Oakland Civic Center. The dignified, classical mien of Forbes Field is matched by that of its patrons, who are being accosted by newsboys on the street after a game. (JDS.)

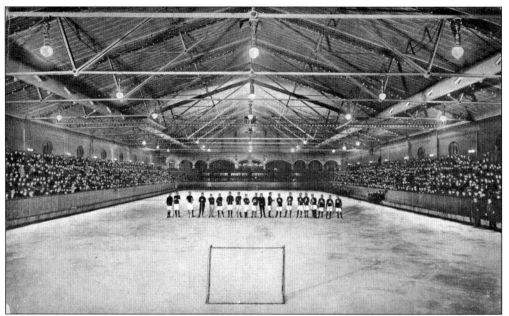

The Duquesne Garden was a redbrick Romanesque trolley barn built in 1890 on Craig Street near Fifth Avenue in Oakland. In 1899, it was converted into an ice-skating rink and arena. This postcard commemorates a 1901 Pittsburgh Athletic Club ice hockey match. The garden was also used for concerts, shows, and sporting events, including the hockey games of the Pittsburgh Hornets. It was demolished in 1956 for an apartment building.

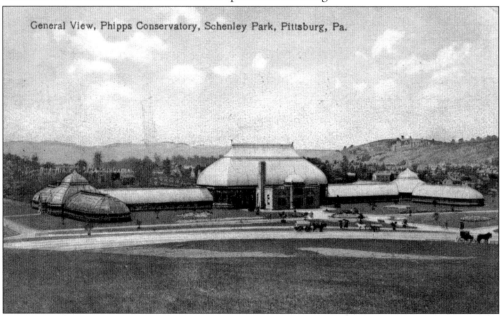

After his gift of a conservatory to Allegheny, Henry Phipps offered another to the city of Pittsburgh in 1891 to adorn the new Schenley Park. By 1893, Lord and Burnham, the great greenhouse builders, had constructed nine display rooms at the foot of Flagstaff Hill, as depicted in this 1910 postcard. The centerpiece of the conservatory was and remains the great palm house, rising above the original Romanesque entrance pavilion. (JDS.)

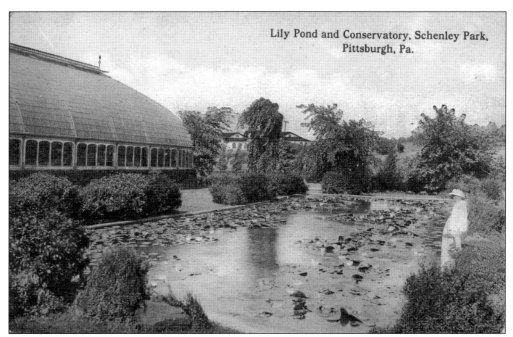

The lily pond at the north end of Phipps Conservatory, seen here about 1910, has been a favorite part of the conservatory experience for generations of Pittsburghers. The absence of tall trees allows a view of several of the buildings at Carnegie Institute of Technology in the distance across Flagstaff Hill. (JDS.)

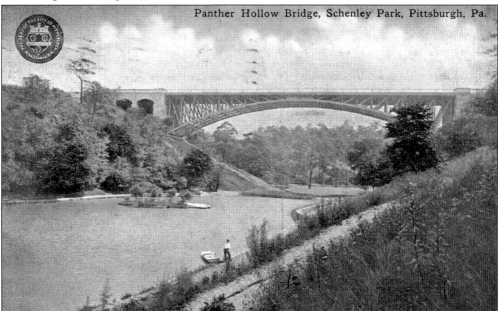

When Mary Croghan Schenley donated Schenley Park to the city in 1889, the land was a wilderness of hillsides and ravines. Almost all the features of the park are man-made. This postcard from around 1910 shows the bridge over Panther Hollow (completed 1897) and a lone boatman enjoying the lake that was developed below. The bridge remains; the lake silted up but is now being restored. (JDS.)

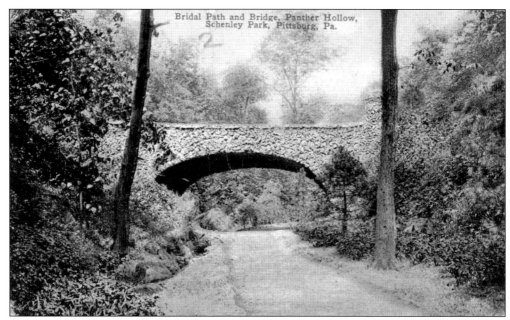

Among the pastimes enjoyed by users of Schenley Park was horseback riding, and in 1908, a bridle path was laid out in Panther Hollow (not a "bridal" path, as this 1917 postcard proclaims). The bridge was designed as a reinforced concrete arch with a facing of tufa stone from Ohio, which gave it a natural look in keeping with the rustic features of the surrounding park.

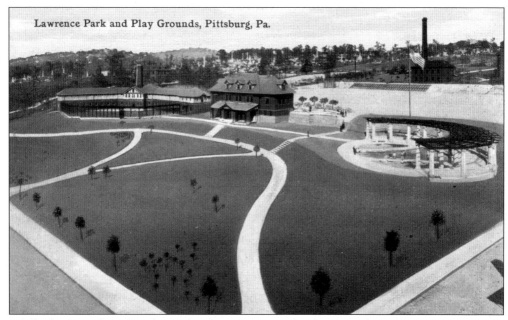

While the City of Pittsburgh was developing its major landscape parks in the late 19th century, it was also providing smaller recreational parks in crowded neighborhoods. Lawrence Park in Lawrenceville (now known as Leslie Park), shown here in 1905, was equipped with a swimming pool, gymnasium, and outdoor play area. The Allegheny Cemetery can be seen behind the bathhouse building on the left. (JDS.)